THE GREAT ESCAPE OF
EDWARD WHALLEY
AND
WILLIAM GOFFE

THE GREAT ESCAPE OF

EDWARD WHALLEY
AND
WILLIAM GOFFE

SMUGGLED THROUGH CONNECTICUT

CHRISTOPHER PAGLIUCO

Charleston H London

THE
History
PRESS

Published by The History Press
Charleston, SC 29403
www.historypress.net

Front Cover.Top: *Pursuing the Regicides,* from John Warner Barber's *Interesting Events in the History of the United States*, published in 1829, New Haven, Connecticut. The scene depicted is unsubstantiated. *Courtesy of Raether Library, Trinity College.*
Bottom: *Judges Cave*, by G.H. Durrie, 1856. *Courtesy of New Haven Museum.*
Back cover: West Rock, by G.H. Durrie, 1853. *Courtesy of New Haven Museum.*

First published 2012
Second printing 2013

Manufactured in the United States

ISBN 978.1.60949.302.8

Library of Congress CIP data applied for.

CONTENTS

CONTENTS

PREFACE

During the nineteenth century, the lives of Edward Whalley and William Goffe were common narratives of American literature and topics of historical study. Unfortunately, with the turn of the twentieth century, they have faded further and further from American memory and the written page, their dramatic story eclipsed by subsequent wars and social movements. While they have more recently been the subject of numerous scholarly articles and fictional accounts, a complete history of their lives has not appeared in book form in more than seventy years. The purpose of this book is two-fold. The first is to compile and synthesize the most important secondary works ever written about the lives of Edward Whalley and William Goffe in England, both old and New, into a single volume. The second is to rekindle interest in the two old colonels, who are compelling in their own right, but who also represent a fascinating bridge between the larger important histories of the English civil war and the formative years of the New England colonies. Perhaps this book will inspire readers to further investigate this special time. With this goal in mind, I have updated the spelling in all primary source quotations to avoid distraction.

The writing of this book was certainly a team effort, and I would like to thank the many people who have helped make it a reality. First and foremost, thank you to my family, whom I have relied on in so many ways from the beginning. My wife, Meghan, literally helped to "make time" in our impossibly busy lives for me to write. She provided a patient ear for my endless ideas, both good and bad, until we could work them out. My

mother, Linda, has edited my earliest crayon drawings right up through to this project, and my writing ability remains a work in progress. This book posed many daunting challenges, and she was by my side to meet each of them. Thank you. My father, Tony, always provided me with an honest opinion and followed it with a gentle push forward. Editor Jennifer Huget's tireless work spent on this project turned the crunchy text into smooth. I will always appreciate her time, effort and friendship. Professor Borden Painter's nuanced historical eye provided valuable guidance and insight into the writing process. Mary Donohue, whose confidence in me is reassuring, has been an invaluable personal and professional resource. Nicole Marino's photography and advice have been a joy. The library at the New Haven Museum, Raether Library at Trinity College and Homer Babbidge Library at the University of Connecticut were particularly helpful in the acquisition of resources. I would also like to thank The History Press for believing in the value of this story and for their support throughout the process.

TIMELINE

Events in the Lives of Whalley and Goffe	Relevant Events of English and Colonial History
	-1625 King Charles I is crowned King
	-1629 Beginning of Charles's eleven-year Era of Personal Rule
Whalley in Essex as a woolen draper Goffe working in London as a grocer	
	-1642 First civil war begins, Battle of Edgehill
Whalley at Marston Moor **1644-** Whalley at Naseby **1645-**	
Whalley guards Charles I, Goffe at Putney **1647-**	
	-1649 Trial and execution of Charles I
Whalley and Goffe at Battle of Dunbar **1650-**	

Events in the Lives of Whalley and Goffe	Relevant Events of English and Colonial History
Whalley and Goffe at Battle of Worcester **1651**-	
	-**1653** Establishment of the Protectorate
Whalley and Goffe rule as major generals **1655**-	
	-**1658** Cromwell's death
	-**1660** Restoration of King Charles II
May, escape to Boston **1660**-	
February, move to New Haven **1661**-	
Move to Milford **1662**-	
Move to Hadley, MA **1664**-	
Approximate year of Whalley's death **1675**-	
"Angel of Hadley" legend **1676**- Goffe's move to Hartford, CT	
Last letter from Goffe **1679**-	
	-**1685** Charles II's death, accession of James II
	-**1686** Dominion of New England established
	-**1688** Glorious Revolution
	-**1689** Dominion of New England overthrown

INTRODUCTION

In the years leading up to the American Revolution, colonial leaders scavenged for every shred of evidence to bolster their case against King George III and Parliament. American literature of the 1760s and 1770s is filled with English constitutional arguments incorporating ideals of representative government proffered by philosophers such as John Locke and James Harrington. These legal and philosophical arguments were central to the growing resistance movement. That movement also drew on historical precedents to justify colonial opposition. History could motivate and provide confidence to the populace in the harrowing days leading up to war in a way like no other.

New England's 150-year history of defending its rights was real and tangible to its citizens, to whom ancestry was important. Many pamphlets debating the issues of the Revolution were written under the pseudonyms of the titans of America's earliest history. John Adams, for instance, wrote as John Winthrop, the Puritan father of New England. As early as 1765, in his *A Dissertation on the Canon and Feudal Law*, Adams drew heavily upon New England's past: "Let us read and recollect and impress upon our souls the views and ends of our own more immediate forefathers, in exchanging their native country for a dreary, inhospitable wilderness. Let us examine into the nature of that power, and the cruelty of that oppression, which drove them from their homes." Adams rallied New Englanders to action by personalizing the conflict. Their grandparents and great-grandparents had fought for freedom, and now it was their turn, their responsibility, to

protect it. "Let us recollect it was liberty, the hope of liberty for themselves and us and ours, which conquered all discouragements, dangers, and trials." In moving forward, Adams urged, "Let us…set before us the conduct of our own British ancestors, who have defended for us the inherent rights of mankind against foreign and domestic tyrants and usurpers, against arbitrary kings and cruel priests, in short, against the gates of earth and hell."[1] The lives of Edward Whalley and William Goffe are an important part of that history, history that Adams so proudly recalled and used to motivate his own generation of rebels.

CHAPTER 1
HOT PROTESTANTS

Like so many others of the period, little is known of the early lives of either Edward Whalley or William Goffe prior to the English civil war. Both men came from humble origins, not noteworthy for any particular reason. Whalley was raised in England's midlands in the county of Nottingham, in Screveton, as the second son of Richard Whalley and Francis Cromwell. Although once powerful, the Cromwell family was, by the time of Whalley's birth, in decline. Whalley grew up with his cousin, Oliver Cromwell, who, in time, became the most important connection in Edward Whalley's life and also in Goffe's. The Whalley family was of a slightly higher social status than Goffe's. In 1595, when Whalley was just a boy, his paternal grandfather served as the sheriff of Nottinghamshire. Whalley attended Emmanuel College, Cambridge, graduating in 1617 or 1618. In 1619, he began his career, apprenticed to Nathaniel Bushere of the Merchant Taylors' Company in London.[2]

There is evidence that William Goffe, who was probably ten to fifteen years younger than Whalley, was born in Haverfordwest, Wales, and it is likely that he was raised in Sussex, England.[3] There is little mystery about how Goffe must have acquired his strong Puritan principles, for his father, Stephen, was a passionate Puritan rector in the town of Bramber, Sussex. In 1605, Stephen was fired from that position for his role in organizing Puritan petitions to King James I. Surprisingly, William's older brother, also named Stephen, later fought on the side of the king in the civil war and even converted to Roman Catholicism; this occurrence, not uncommon, reveals

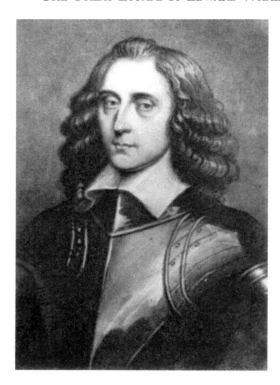

This picture, purportedly of William Goffe, shows Goffe as he would have appeared during the English civil wars. There are no known images of Edward Whalley. *Courtesy of Homer Babbidge Library, University of Connecticut.*

the complexities of allegiance during this turbulent time.[4] Although little else is known about Whalley and Goffe, what is certain is that during this era they were each overcome with a Puritan fervor that soon became the single most important force in their lives.

During the 1630s, Whalley, Goffe and their fellow Puritans made up just one of many factions hostile toward King Charles I. Puritans were by no means a majority in England. In fact, early on, the word "Puritan" was derogatory, equivalent to calling someone today a bigot, killjoy or extremist.[5] Nor did Puritans use the term when referring to themselves; they preferred to be called "Hot Protestants" or "The Elect." While Puritans were not alone in inciting the English civil war, their later prominence owes largely to the fact that they were the ones who ended it. Convinced that apocalyptic forces were at work in the world, Whalley, Goffe and other Puritans felt that they had an obligation to God and to mankind to purge England of its sins before it was too late, before Judgment Day.

The Puritan cause, so important to Whalley and Goffe, originated nearly one hundred years earlier when Henry VIII broke from the Roman Catholic

Church, creating the Church of England (also known as the Anglican Church) in the process. Henry's chief motive was to find a legal way to divorce his wife, Catherine of Aragon, not to fully embrace Protestant theology, practices and values. But that was not enough for England's true Protestants, many of whom sought to "purify" the Church of England of all Catholic qualities, hence the name "Puritan." In the ensuing century, the Church of England swung like a pendulum between Catholic and Protestant doctrine, according to the whims or convictions of each new monarch. Each swing created a new generation of heroes and martyrs on each side. Puritan theologian Thomas Hooker, who became the founder of Connecticut Colony, captured the gist of the Puritan perspective when he said that Henry VIII's mistake "was that he cut off the head of Popery, but left the body of it yet within his realm!"[6]

King Charles I was no Puritan. In fact, it was suspected that he was the worst possible alternative: a Roman Catholic. English Catholics had a history of butchering Protestants in England; abroad, the Catholic and Protestants were busy slaughtering one another across Europe in the Thirty Years' War (1618–48). Charles's marriage to the French-born Catholic Henrietta Maria shortly after he ascended to the throne in 1626 was an inauspicious start to his reign. He then proceeded to make life easier for English Catholics by easing old restrictions on their worship. He also reopened diplomatic relations with the pope for the first time since Henry XIII.[7] In 1633, he appointed William Laud as his archbishop of Canterbury, the most important church position in England. Laud was well known for his support of Arminianism, the Protestant sect most closely aligned with Catholicism. Even worse, Laud used a heavy hand in church matters, leaving little room for variation in religious worship. From something so seemingly trivial as the clothes (vestments) of a minister to the strict control of church services through his implementation of the *Book of Common Prayer*, Laud's reforms were thorough, rigorous and flat-out hostile toward the core beliefs of Puritanism.

What was most offensive to Puritans and other Protestant sects was Archbishop Laud and King Charles's insistence on tight control of church government. Both Laud and Charles strongly favored the use of bishops (or episcopacy), who were appointed by the king, to dictate every aspect of worship in church. This was offensive to the freedom of conscience Puritans held so dear. King James I, Charles I's father, bluntly stated the importance of bishops to a monarch when he proclaimed in 1604, "No

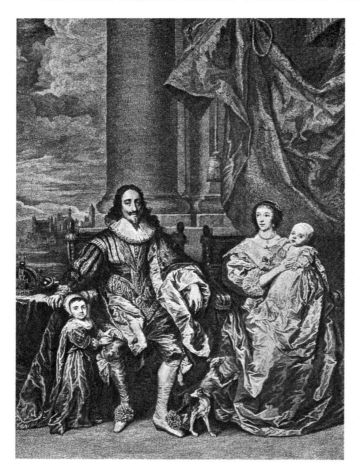

An engraving of *Charles I and Queen Henrietta Maria with Charles, Prince of Wales and Princess Mary*, 1632. Charles's Catholic wife, Henrietta Maria, and the prospect she raised of future Catholic monarchs alarmed English Protestants in the years preceding the civil wars. *Courtesy of Raether Library, Trinity College.*

bishop, no king." Charles inherited his father's opinion. Bishops were antithetical to the Puritan tenet that truth lies only in the Bible, not in what men say. Charles viewed the freethinking Puritans as subversive. In essence, King Charles I and England's Puritans were fighting one another over control of the church pulpit and, in turn, the minds of men.

Exclusive, intransigent and fanatic in their religious conviction, Edward Whalley, William Goffe and their Puritan brethren were formidable and dangerous adversaries to the Crown. Central to their belief system was the doctrine of predestination, which held that there was nothing people could do on Earth to help them get into heaven. Instead, they believed that God selected certain people, called saints, to go to heaven, and that determination was made by God before they were even born.

Being part of "The Elect" provided a righteousness and certainty to the Puritan character that was a powerful political, and later military, tool. Their reading of the apocalyptic *Book of Revelation* convinced Whalley and Goffe that they were living in the fifth and final period of Church history, when "the forces of Christ and the forces of the Anti-Christ were locked in battle; the ultimate outcome would be the final triumph of the true reformed church."[8] Puritans felt that England had a special role to play in this biblical fight and that even their own personal lives were an integral part of God's plan. The rapacious religious policies of Charles I served to further substantiate their beliefs. Puritans experienced a deep sense of urgency to their circumstances, and it drove them to extreme lengths.

To be fair to Charles, Puritans were not the easiest people to rule. They were only too eager to view each of Charles's policies as part of a larger, sinister scheme. Yet the insolence of his rule brought out the worst in an already contentious circumstance. He severely underestimated determination of his Puritan opposition until the end.

In this charged atmosphere, some Puritans were driven to flee "civilized" England for the wilderness of America. Determined to create their own model Puritan society, about forty thousand fled during the 1620s and 1630s in the Great Migration. However, far more Puritans, the vast majority, chose to stay in England and "save" their country rather than flee it. While John Winthrop was building his "city upon a hill" across the sea in Boston, Whalley and Goffe were waiting patiently to strike and bring about Godly Reformation to England.

CHAPTER 2

THE GOOD OLD CAUSE

As businessmen and fiery Puritans from Greater London at this time, Whalley and Goffe certainly followed the alarming events of their day. In the 1620s, Whalley was at work in London as an apprentice to a woolen draper (a trader of woolen goods). After nearly ten years, he became a member of the Merchant Taylors' Company, and in 1626, he married his first wife, Judith Duffell. Edward and Judith had two children: a son, John, and a daughter, Frances. Thereafter, Whalley appears to have relocated, first to Chadwell, Essex, and then to Scotland, possibly on the run from creditors.[9] William Goffe was also living in London, apprenticed to a grocer, William Vaughan. In 1642, he became a freeman of the Grocer's Company.[10] On an unknown date, he married Frances Whalley, Edward Whalley's daughter, and in time had three daughters of his own: Anne, Elizabeth and Frances. This marriage either started or cemented a relationship with Edward that would last for the rest of their lives. Although neither man was enjoying an illustrious career, the coming civil war forever changed their fortunes.

Charles's economic policies did not make Whalley's and Goffe's already restricted financial lives any easier. After a series of hostile and belligerent Parliaments in the 1620s, Charles decided to try to rule England without ever calling a Parliament again. His only real use for Parliament was in the approval of taxes. As long as he could raise enough money in other ways to run his kingdom, he saw no need to call a Parliament or make any political or religious concessions. Charles used all available methods, both legal and illegal, to squeeze every last shilling from his realm.

Charles created dubious ways of creating new sources of revenue. His officials arrested innocent people on fraudulent charges and required them to pay for their release. Conversely, true criminals could also escape imprisonment through the payment of a fine. He began forcing landowning citizens to apply for knighthood and other titles, only to charge new, exorbitant fees to obtain them. Under threat of arrest, Charles demanded loans from individuals, businesses and towns, loans he had no intention of paying back. He also increased fines for hunting in royal forests by using land deeds that broadened the size of his hunting grounds that had not been used in four hundred years.[11] By far Charles's most infamous tax was called ship money. Formerly only collected in coastal towns to pay for naval protection, Charles expanded the collection of ship money across the country. The expansion of the tax to interior towns without the consent of Parliament was the center of a famous court case brought to the Court of the Exchequer Chamber by Parliamentarian leader John Hampton. The trial quickly captured national attention. Although the king won the case, the narrow seven-to-five decision by the king's own judges was viewed as a victory for Hampton and Parliament. These desperate and illegal economic policies united not only Puritans but also many other Englishmen against their tyrannical king.

To enforce these laws, Charles corrupted the justice system. He appointed crony judges who were willing to support his policies and excessively fined or replaced those who were not. His courts, called the Star Chamber (for temporal matters) and the Court of High Commission (for spiritual), met in secret and then handed out dreadful, seemingly arbitrary sentences. Charles began confiscating property and arresting his critics. Horrific sentences including public whipping, ear cropping, cheek and forehead branding, nose slitting and indefinite imprisonment were issued by his judges and represented visible proof of his tyranny.

At the onset of the war, very few, if any, Englishmen were inherently anti-monarchical in their thinking. It was treasonous to accuse the king of wrongdoing, and no one, not even Whalley or Goffe, wished to challenge that axiom. What Parliament really wanted was for Charles to change his policies. One way to accomplish that goal was to target his closest advisors, but Charles refused to call a Parliament, depriving his people of a voice. That fact changed when Charles tried to force bishops and the *Book of Common Prayer* onto his other kingdom, Presbyterian Scotland. The Scots promptly responded by raising an army and invading England. War was

something that Charles could literally ill afford, and he was finally forced to call a Parliament to raise funds for an army to fight the Scots.

With eleven years of pent-up frustration and the king at last in a vulnerable position, Whalley and Goffe were counting on Parliament to reassert their religious and political rights as Englishmen. Parliament seized the opportunity and took firm hold of power. Because they looked upon the Scots as friends, they did not share Charles's urgency to put down the invasion. Ignoring the Scottish threat, Parliament focused on reining in its king. Instead of attacking the institution of monarchy, it targeted Charles's advisors, policies and courts. Archbishop Laud's changes to worship ceremonies were declared illegal. Laud was impeached for treason, imprisoned and then executed. Charles's other chief advisor, the Earl of Strafford, was likewise impeached and later beheaded; 200,000 Londoners attended his execution. Unlawful taxes were overturned. The Star Chamber and Court of High Commission were abolished and their victims released. Yet Parliament did not just try to undo the abuses of the preceding sixteen years; it also worked to set in place protection against such violations in the future, passing, for instance, a law requiring Parliament to meet every three years and another prohibiting the dissolution of Parliament without parliamentary consent.

In the midst of these sweeping and dramatic changes, a series of events brought tensions in London to a boiling point. A rebellion broke out in Catholic Ireland, sparking rumors and fears of a massacre. Reports that forty thousand Protestants had been killed and rumors of conspiracies implicating Charles were rampant. In this contemptuous atmosphere, both sides scorned compromise and pressed for the total defeat of the other. "The pressure of events forced parliamentary leadership to take radical steps they would not have even considered twelve months before," wrote noted civil war historian Barry Coward in *The Stuart Age: A History of England 1603–1714*.[12] In November 1641, Parliament drew up the "Grand Petition and Remonstrance," a list of all the grievances experienced from the beginning of Charles's reign, but the document passed by only a slim majority.

Recognizing division among Parliament, Charles sensed an opportunity to strike. He singled out five parliamentary leaders—John Pym, John Hampden, Denzil Holles, Sir Arthur Haselrig and William Strode—to illegally arrest. With five hundred soldiers, he stormed Parliament in order to seize the men, only to find that they had escaped at the last minute. "The birds have flown," Charles famously proclaimed.[13] News of the illegal plot

was leaked; it was further proof of Charles's disregard for Parliament and the law. The constitutional role of the king would not be determined through acts of Parliament. King Charles I and Parliament prepared to go to war. It was not to be the last time this strategy of seizing parliamentary divisions would fail for Charles with disastrous results.

Although the reign of Charles I was horrific, decades later many Englishmen yearned for a return to this purer, simpler time when their cause was clear. Parliament was defending its constitutional rights from a tyrannical king. This sentiment, captured in the phrase "the Good Old Cause," resonated with many Englishmen in its call for a return to their original sound parliamentary government that was later contorted by the convulsive social and political upheaval that took place in the war-ravaged country.

CHAPTER 3

IRONSIDES

As mere commoners, Whalley and Goffe could only follow these political whirlwinds from the outside. Goffe's arrest in 1642 for his role in circulating a petition to give control of the militia to Parliament shows that he was actively engaged in the issues.[14] The fact that the petition concerned control of the militia suggests that Goffe shared Parliament's deep distrust of Charles. Part of what made the English civil war so significant and intriguing was that the war itself fundamentally transformed English society. The sheer destruction caused by the war provided opportunities for Whalley and Goffe to climb to a level of national prominence never otherwise possible. Although Charles could never have known it at the time, it would have been far easier to negotiate with Parliament early in the war than it would be to deal with the likes of Whalley and Goffe at the end.

Goffe began his military career as a cornet, the lowest-ranking military officer, in the cavalry troop of John Fiennes. Fiennes was the son of the incredibly influential English viscount Saye and Sele. It was Edward Whalley, however, who found himself at the center of the action, playing a central role in the most pivotal battles of the war.

Whalley may have also began as a cornet in the Earl of Essex's army and thus fought in the first battle of the war, Edgehill.[15] After ten months of preparations, Charles's forces began an advance on London, a parliamentary stronghold, and the two armies fought to a draw on the vale of Red Horse in Warwickshire. While it quickly became clear that neither side was going to achieve a quick and decisive knockout blow, a seed was

planted in this fight that would ultimately determine the outcome of the entire war. Although he arrived too late to influence the result, Oliver Cromwell was able to observe the action on the battlefield. He noted the high quality of the king's men and concluded that he would need men of superior conviction to be victorious, not, as he put it, "mere'serving men and tapsters."[16] In a famous report to the Suffolk commissioners shortly thereafter in 1643, Cromwell stated, "If you choose godly honest men to be captains of horse, honest men will follow them...I had rather have a plain russet coated captain that knows what he fights for and loves what he knows, than that which you call a gentleman and is nothing else."[17] In his cousin Edward Whalley, Cromwell found his man. In March 1643, the same year Cromwell wrote about "godly honest men," Whalley was promoted to captain in Cromwell's newly formed regiment of horse.[18]

Whalley quickly distinguished himself under Cromwell at the Battle of Gainsborough in 1643. After he led a brilliant charge up a sandy hill to overwhelm Royalist forces, thereby seizing control of the town, a much larger Royalist force arrived and forced Cromwell's withdrawal. Major Whalley held off the larger Royalist army while the rest of Cromwell's forces retreated. Only two men were lost in this dangerous situation. Cromwell gave credit to Whalley for his role: "The honor of this retreat, equal to any of late times, is due to Major Whalley and Captain Ayscough, next under God." In a report to Parliament, Cromwell noted that Whalley had fought "with all the gallantry becoming a gentleman and a Christian." Whalley received a promotion to the rank of colonel and fought under Cromwell for the duration of the 1640s.[19]

Marston Moor was the first major battle to reveal the devastating effectiveness of Cromwell's cavalry under Whalley's battlefield command. On July 2, 1644, some Royalist forces, under the command of the dashing Prince Rupert, King Charles's nephew, caught up to combined Scottish and parliamentary forces on Marston Moor. The thick grasses and mud associated with the broad slopes of a moor provided Rupert with a superior defensive position. Rupert's men, however, did not all arrive at the battlefield at the same time, complicating his battle plans.[20] Whalley was a leader of Cromwell's horse, or cavalry, and he and his men were exceptionally well drilled. They were known for being able to ride, charge, even turn, knee to knee, in such close formation as to maximize impact. At least as important was the fact that they were as well disciplined off the battlefield as on. Unlike Rupert, Cromwell could effectively regroup his cavalry, under Whalley's

leadership, after a charge allowing them to attack again in the same battle. This new battlefield discipline made all the difference in the Battle of Marston Moor.[21] Under the pelting rain of a thunderstorm on a hot summer night, Cromwell and Whalley charged and defeated Lord Byron's Royalists on the right flank of the field, forcing Rupert to personally lead a counterattack against them. But Rupert, unhorsed and wounded, was defeated. Instead of laying chase, Cromwell reorganized his men and attacked the Royalists from behind, effectively turning the tide of the battle and clinching victory. In only two hours, Parliament gained a major victory over Prince Rupert and took control of all of northern England.

In the wake of the Battle of Marston Moor, Rupert nicknamed Cromwell "Old Ironsides." Cromwell's cavalry division, half of which was led by Whalley, became known as the Ironsides. Reflecting on the battle, Cromwell said, "God made them stubble to our swords…Give glory, all the glory, to God."[22] This quote shows a growing and important trend in the thinking of Cromwell and his men. More and more, in their victories and now with their voices, these men saw the hand of God. This gave parliamentary soldiers confidence and added moral strength to their cause. Their victories on the battlefield stood as signs that God approved of their political aims.

Despite the parliamentary victory at Marston Moor, 1644 ended in stalemate. In a war-weary Parliament, unity was beginning to fracture. Cromwell, and many in the army, felt that some parliamentarians were holding out for peace through negotiation rather than victory through force. After officers traded accusations, the Self-Denying Ordinance—the term "self-denial" echoing the language of Puritan and Presbyterian values—was proposed. Its passage prohibited officers in the military from simultaneously serving as members of Parliament.[23]

This meant the army could now focus solely on achieving victory on the battlefield without concern for parliamentary politics. Parliament also instituted wholesale changes to its military forces, including the creation of the New Model Army. The New Model Army included reforms that made it in many ways the first modern army. Its soldiers were promoted based on merit alone rather than social rank. Rigorous training and regular pay (however limited) were introduced and resulted in a much more disciplined fighting force on and off the battlefield. William Goffe, whose service in the civil war to this point is undocumented, is listed as a captain in Colonel Harley's regiment in the New Model Army in April 1645.[24] Whalley remained in command of one of Cromwell's two personal cavalry regiments. With one

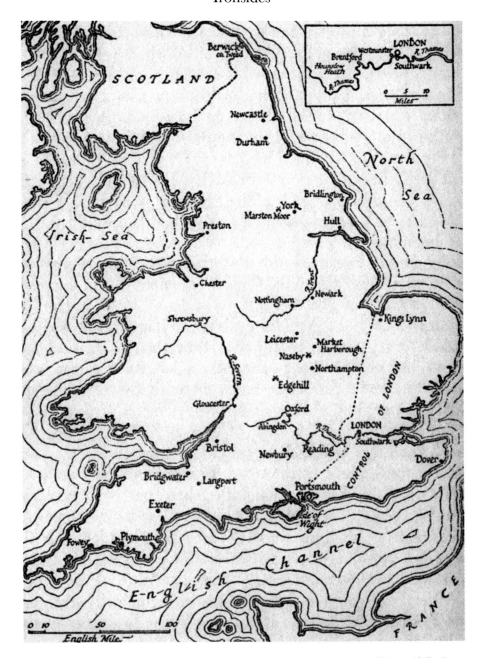

A map of the principal cities and battlefields of the first English civil war. Edward Whalley figured prominently in the Battles of Marston Moor (1644) and Naseby (1645). *Courtesy of Raether Library, Trinity College.*

primary army under the command of a single man, the idiosyncrasies and disconcerted actions of regional armies and militia of the past were reduced or eliminated.

In 1645, Charles was eager to challenge the newly organized parliamentary forces. "The New Noddle Army" mocked Royalist soldiers ("noddle" being an English term for head or brain, similar to the American term "noodle"). Charles drew the New Model Army away from its siege of Oxford, and the two armies met at Naseby on June 14. Whalley again served in a crucial role in what would become his most significant military triumph. The battle began with Rupert's cavalry cutting through the parliamentary flank and racing off the battlefield to raid the parliamentary baggage train, as was customary. Cromwell was the last to charge. Opposite Rupert, yelling, "God is our strength!" Whalley and his men were among the first to engage, firing their pistols at point-blank range and then drawing their swords.[25] Whalley and his men routed Sir Marmaduke Langdale's cavalry. Unlike Rupert, however, Cromwell next divided his forces. Sending only some of them after Langdale, he had the remainder regroup and attack the Royalist infantry in the center. This proved too much for the Royalists, and they surrendered. By the time Rupert returned to the field, the battle was nearly over, and his horses were too tired to attack again. Cromwell's men captured four thousand veteran Royalist soldiers, all their artillery and even pieces of Charles's private correspondence. Cromwell concluded, "Naseby was none other than the hand of God and to him alone belongs the victory."[26] To Cromwell and his fellow Puritans, God was justifying their actions by awarding them victory.

CHAPTER 4
THE PUTNEY DEBATES

After Naseby, Whalley gained even more stature. Few officers were more active at this stage of the war. In 1645, he participated in key Roundhead victories at Langport, Sherborne Castle and Bristol, and in 1646 at Exeter, Oxford and Banbury. For his storming of Banbury Castle, Parliament voted to give him one hundred pounds toward the purchase of two horses.[27]

Whalley's military victories limited King Charles's prospects for total victory, but Charles was not about to give up. What he could not achieve on the battlefield, he would win at the negotiating table. Unfortunately, negotiations did not begin any better for the king. In the wake of Naseby, Charles's private papers were captured and then published for all to see. Entitled *The King's Cabinet Opened*, his papers exposed his duplicitous character. For instance, they revealed that even as he appeared to be negotiating a peace settlement with Parliament, Charles was simultaneously trying to hire French mercenaries to fight on his behalf. All along, he had been disingenuous in negotiations. Even more horrifying, in exchange for the aid of French troops, Charles gave Queen Henrietta Maria the "power to promise in my name (to whom thou thinkest most fit) that I will take away all the penal laws against Roman Catholics in England."[28] The war apparently had not humbled England's tyrannical king. Instead, it appeared to produce the opposite effect. Incredibly, he was intensifying his old policies.

As at the start of the war, Charles again sought to exploit parliamentary disunity and played for time. The French ambassador to London, Pompone de Bellievre, reported to Paris that "the King was resolved to do nothing in

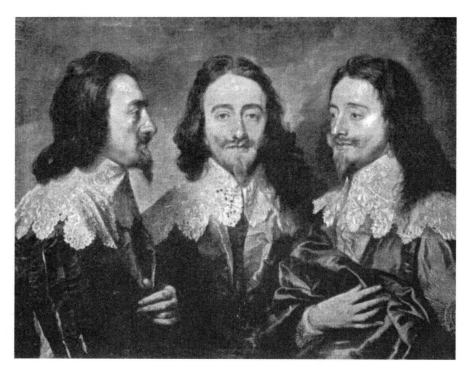

This triple portrait of King Charles I by Anthony van Dyke is interesting in its suggestion of the many facets of Charles I's personality. *Courtesy of Raether Library, Trinity College.*

order to give peace to the kingdom and that he was certain that by taking patience for six months everything will be upset so that his affairs would arrange themselves without his having anything to do with them."[29] In the wake of his defeat at Naseby, King Charles did not seek a peaceful, lasting settlement with Parliament; his true aim remained to restore his powers to their prewar status. The rifts Charles anticipated quickly became a reality. The longer Charles held out, the more factions emerged. He gambled that by pitting the factions against one another, he could negotiate his way to victory.

The parliamentary side, so united in war, splintered in peace. Initially, the Scots and Parliament were united together through their common religious preference, Presbyterianism. Socially, Parliament was relatively conservative and eager to preserve the existing power structure. As the representative body elected by the people, Parliament felt most justified to be the sole negotiator with the king. These reforms were significant, but they did not go far enough religiously or socially for many Puritans.

Opposite Parliament were the Independents in the army. The Independents were an alliance of countless disenfranchised groups all opposed to Parliament and the king. They were led by officers, like Cromwell, Whalley and Goffe, who were guided by their extreme Puritanism. The soldiers, however, maintained far more secular goals. They formed a faction called the Levellers that focused on increasingly democratic social and political changes. Although the officers and Levellers did not always see eye to eye, they were united by their bond forged on the battlefield, if not by their shared opposition to both Charles and Parliament. Initially a military arm of Parliament, the army was transforming into a completely separate political entity. Whalley and Goffe, two of the most Puritan of officers, each commanded regiments consisting of some of the most radical Levellers in the entire army. It was not Parliament that defeated Charles; after all, the war was a stalemate until the Self-Denying Ordinance. The army that had defeated Charles felt entitled to have its interests represented in negotiations.

Sensing the army's anger and unrest, the Presbyterian-dominated Parliament came to view the army to be as much of a threat as Charles and thus sought to disband the army as quickly as possible. Offended by Parliament's disrespect, the army drafted a petition to leadership seeking security for back pay owed to soldiers, payments for men injured in war, pensions for soldiers' widows and orphans and other military benefits. Parliament sent Oliver Cromwell, the only man with a foot planted in both the army and Parliament, to bridge the differences between the two sides. At army headquarters at Saffron Waldon, Essex, Cromwell met with the soldiers.[30] At the meetings, Whalley served as an intermediary between his angry soldiers and Cromwell. Whalley advocated for his men by appealing to Cromwell to grant more time for the soldiers' grievances to be addressed.[31] There was a growing feeling among the troops that the Presbyterians were ignoring the interests of the soldiers, the very people who had won the war, in Parliament's peace negotiations with the king. The meetings failed, and in March 1647, Parliament responded to the army with hostility, passing what came to be known as the "Declaration of Dislike for the Army." The declaration derided the soldiers as being "enemies of the state and disturbers of the public peace."[32]

With tension escalating, William Goffe, as one of the most radical Puritan officers, pushed the army and its officers to extreme ends. In June 1647, Goffe and other members of his commission called for the impeachment of eleven Presbyterian leaders for corruption and other offenses. He declared that heaven was against Charles and that the troubles of England were

due to Parliament's longtime dallying with evil men.[33] These dangerous sentiments were rapidly gaining support in the ranks of the army. Interpreting their actions as mandated by God's will changed the dynamics of the dispute. Until now, the fight with Charles had been constitutional in nature. The assignment of powers to the English monarchy within the English constitution was the central dispute. Goffe's statements began to change what was a constitutional dispute into a moral, religious fight. The dispute had transformed into a question of the king's guilt for crimes against the country and God. For its part, Parliament issued an order to the New Model Army: serve in Ireland or disband. Instead of making a choice, the army created a third option: mutiny. It resolved not to disband until all of its grievances were addressed. Two days after Parliament's order, army soldiers secretly marched to Holdenby House, a royal residence, and seized the king to prevent Parliament from negotiating a treaty with him.

In the fall of 1647, Whalley was in charge of enforcing Charles's captivity at his royal palace, Hampton Court. While there, Whalley received an order from Parliament to deprive Charles of his chaplains during his captivity. Whalley disregarded this order on the grounds that his commander, Fairfax, had not issued it. While Charles interpreted and appreciated Whalley's gesture as an act of kindness, it showed where Whalley's loyalties lay: with

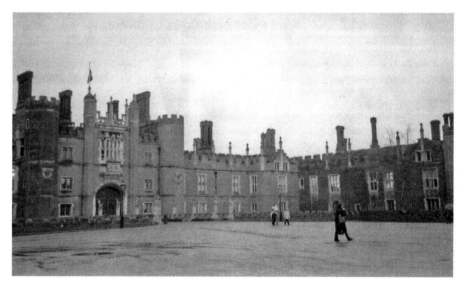

It was in the enormous royal palace Hampton Court that Edward Whalley had the responsibility of guarding the king.

the army. At Hampton Court, Cromwell and other officers pressed Charles hard to find a settlement, even visiting Charles with their wives, hoping their presence might help soften his stance. It was important for Cromwell, a man who respected the law, to avoid finding a solution by force.

Meanwhile, the army created a governing body called the Council of the Army to represent the soldiers' interests. Cromwell, sensing the destruction of the parliamentary side, took a turn at restoring the king. Having recognized that Parliament could be as tyrannical as a king, Cromwell's settlement, called the Heads of the Proposals, included reforms to both corrupt government bodies. Although his proposal was far more moderate than many Independents hoped, the weight of Cromwell behind it would have ensured its approval. Unwisely, Charles still refused. "You cannot do without me; you will fall to ruin if I do not sustain you," he countered.[34]

Charles was correct in his prediction. For when Cromwell was not negotiating with Charles, he needed to attend meetings at army headquarters in Putney (seven miles north of London) to try to hold his army together. Civilian Levellers, army representatives (called agitators) and officers (called Grandees) were all pushing Cromwell to more radical ends than a negotiated settlement. William Goffe played an important role in these proceedings. For fifteen days, beginning on October 28, the army debated the right of men to vote, as well as the role, if any, that the king would play in the nation's future, among other political issues. These debates have been credited as being key to the development of modern concepts of democracy and liberalism.[35] "They appear to be the first recorded expression of demands for universal manhood suffrage within a representative system of government," writes Samuel Glover in his *The Putney Debates: Popular versus Élitist Republicanism*.[36] On the first day of the debates, Goffe called for a more religious tone to meetings. "Let us not be ashamed to declare to all the world that our counsels and our wisdom and our ways, they are not altogether such as the world hath walked in; but that we have had a dependency upon God, and that our desires are to follow God," he pleaded on the first day of the meetings.[37] Goffe was sure that no project would prosper "unless God be first sought."[38] The following day, Goffe concluded from his biblical studies that the second coming of Christ was imminent. "Now the word doth hold out in the Revelation, that in this work of Jesus Christ he shall have a company of Saints to follow him, such as are chosen and called and faithful. Now it is a scruple among the Saints, how far they should use the sword; yet God hath made use of them in that work. Many of them have been employed these five or six years," Goffe proclaimed.[39]

Goffe's apocalyptic rhetoric, called millennial, was an important element in the officers' thinking and was instrumental in determining the fate of the king.[40] Goffe, like many of his fellow officers, saw the hand of God in the army's actions. In his view, Charles was the anti-Christ, and the saints had a duty to destroy him. Goffe was among the first, if not the very first, to call for negotiations with Charles to end and for him to be brought to justice. During the meetings, Goffe stated, "It seems to me evident and clear that this hath been a voice from heaven to us, that we have sinned against the Lord in tampering with his enemies." Cromwell took offense at Goffe's insinuation that he had gone astray, and Goffe was forced to apologize.[41] Nevertheless, Goffe's powerful oratory escalated tensions and shortened patience with Charles. Charles did not appreciate the seriousness of these grave sentiments until it was too late. The debates may have ended without incident on November 11, 1647, but the meeting produced a clear shift of many in the army toward the possibility of abolishing the monarchy altogether.

Back at Hampton Court, Whalley received multiple letters threatening the assassination of the king. Whalley showed these letters to Charles, and on the day the Putney Debates ended, Charles escaped from Hampton Court. It was not difficult for him to escape from the 1,500-room palace. Whalley admitted that he "could no more keep the King there if he had a mind to go than a bird in a pound."[42] Many questions have surrounded Charles's escape, both then and now. In particular, people have long wondered whether Cromwell might have had a role in prompting Charles to take flight. While there is no evidence to prove that he did, Cromwell benefited greatly from the king's escape. With the king at large, unity returned among Cromwell's officers and soldiers. Whalley was ordered by Parliament to present his account of what happened. Satisfied, Parliament exonerated Whalley of any blame.

Charles, eager to escape from the pressures of the army, fled to the isolated Isle of Wight. Charles was held in Carisbrook Castle under the care of governor Colonel Robert Hammond. Finally, Charles's strategy came to fruition. He convinced the Scots to abandon the parliamentary side, return him to the Scottish throne and raise an army to fight on his behalf. All in exchange for just three years of Presbyterian rule. Although Charles remained captive by Parliament, an army of ten thousand Scots assembled and invaded England in concert with a Royalist rebellion. The nation again returned to war.

CHAPTER 5

CHARLES I, THAT MAN OF BLOOD

The second civil war produced opposite effects in Parliament and the army. Parliament, recognizing increasing Royalist support in the country, softened its stance, just as Charles had hoped. As the second English civil war raged, Parliament reopened negotiations with the king, infuriating the army, whose soldiers were dying on the battlefield. The renewed bloodshed disgusted the New Model Army. Soldiers viewed the second civil war as being entirely the fault of a king who was willing to kill his people to preserve his own tyranny.[43]

At the opening of an army prayer meeting at Windsor in April 1648, William Goffe gave a powerful speech advancing his rhetoric from the Putney Debates. Citing the Book of Proverbs in the Old Testament, Goffe asserted that those who did not follow God's plans and purposes must face God's wrath. The outbreak of the second civil war was God's punishment for the army's negotiating with Charles and its failure to bring him to justice. William Allen, a contemporary observer, wrote the following account of the meeting, which reveals the impact of Goffe's speech: "None was able hardly to speak a word to each other for bitter weeping…in the sense and shame of our iniquities of unbelief, base fear of men and carnal consultations (as the fruit thereof) with our own wisdoms and not with the word of the Lord."[44]

In the army, hope for a settlement with Charles was lost. The longer Charles held out, the weaker Parliament's demands became. As long as he was alive, the threat of insurrection loomed. At Windsor, the soldiers resolved "that it was our duty, if ever the Lord brought us back again

in peace, to call Charles Stuart, that man of blood, to an account for that blood he had shed."[45] A man of blood, they believed, was one who shed innocent blood and with whom the Lord would not make peace. "Convinced that Charles was one against whom the Lord had set his face, the Army considered it imperative that he be brought to justice," wrote Patricia Charles in *Charles Stuart, That Man of Blood*.[46] To speak of Charles as a man of blood represented the final stage in the army's interpretation of the war. The crisis was now a moral issue, a question of justice in the eyes of God. The army was now seeking a way to pacify the Lord for the nation's bloodguilt. Following this logic, the second civil war was no longer just about battlefield victories. The war itself became a means of determining God's will. If the New Model Army was victorious, Charles indeed was a man of blood and deserved to be put to death.

The outcome on the battlefield was a predictable: wholesale Royalist defeat. The New Model Army won every contest, this time with merciless force. At Preston, Scottish forces were defeated by a New Model force less than half its size. Ten thousand Scots were taken prisoner, and their commander, General Hamilton, was taken to London and executed.[47] Whalley fought at the Battle of Maidstone and helped to literally starve the Royalists into submission at the Siege of Colchester. Two more Royalist commanders were executed. There was now no question of God's intent and what needed to be done.

CHAPTER 6
MURDERERS OR SAINTS?

By the fall of 1648, tensions were at a fever pitch. Parliament was rightfully afraid of the army taking matters into its own hands. It was a threat that Charles did not perceive. William Goffe and Edward Whalley were both certainly in favor of trying the king. Amid a series of assassinations, violent, raging rioting filled London's streets, fueled by rampant propaganda. Parliament, now desperate to save the king, raced to Charles, who was still on the Isle of Wight, and literally begged him to accept its Treaty of Newport. Hoping to salvage at least some of the principles for which it had fought, its terms were generous and all were negotiable. Sensing Parliament's obvious desperation, and underestimating the danger of his circumstance, Charles foolishly held out. Disingenuous until the end, Charles revealed his plans to string Parliament along with a mock treaty, and once again escape, in a private letter to his advisors in September 1648.[48] On November 17, the army sent Charles a final proposal, only to also be rejected. The army could not stand for another round of negotiations with this duplicitous, tyrannical killer. The next day, in a protest to Parliament called the Grand Remonstrance, the army demanded that negotiations with Charles be terminated, the king be put on trial for treason and a new Parliament be elected to choose a successor.[49] Parliament first delayed action on the Remonstrance in hopes that a treaty would be completed. When those hopes dimmed, it defeated the measure soundly. Many in the army, including Whalley's regiment, were ready and determined to take matters into their own hands, calling for a forced dissolution of Parliament.[50]

As a member of Parliament, Oliver Cromwell respected the law. As events transpired over the next month, he tried to ground proceedings on as much of a sound legal basis as possible. Cromwell insisted on acting through Parliament. Since a forced dissolution of Parliament was outright illegal, army leaders chose to prevent those members of Parliament (or MPs) who were hostile to the army from taking their seats. Whalley served on the committee charged with writing a declaration to justify the purge, revealing his support for the illegal tactic. On December 6 and 7, New Model soldiers from Colonel Pride's regiment surrounded Parliament and prevented any member who favored negotiation from entering in what came to be known as Pride's Purge. At that time, 41 were arrested and held in the basement of the House of Parliament, a location commonly called Hell. They were gradually released over the next two weeks.[51] Another 60 were prevented from entering and turned away. An additional 160 withdrew in protest. Only 40 percent of Parliament remained. Called the Rump Parliament, these MPs became a virtual tool of the army.[52] Although Whalley did not personally purge the Parliament, he witnessed the event as it was happening through his service delivering proposals from the army to the remaining members of Parliament.

The Rump immediately began preparations to try the king. Over the next four weeks, a High Court of Justice was formed to act as a tribunal. As army leaders such as Cromwell returned to London, last-ditch and desperate efforts, both secret and public, were made to restore Charles to the throne. Charles accepted none. The total defeat of the king's forces on the battlefield and two and a half years of negotiation had produced no resolution. As long as Charles remained alive, there would be no peace. The king was to be tried for treason, and if found guilty, his sentence would be execution.

Monarchs in the past had certainly been killed by political adversaries, but always by means other than trial and execution. Some were killed before they took the throne, others by assassination and others through more violent revolutions than this one. Charles was the first to be tried for his life by his own subjects while he held the throne. This was because many of Charles's adversaries were men who respected the law, felt they were acting on behalf of the people and, most importantly, knew God was on their side. Some viewed Whalley, Goffe and their fellow jurors as being law-abiding and honorable men who, at great personal risk and expense, fought for religious and political rights against a tyrannical king who waged war on his own people. Others saw them as radical extremists who were willing to use extra-legal maneuvers to murder King Charles I, a martyr who died for his divine right to rule.

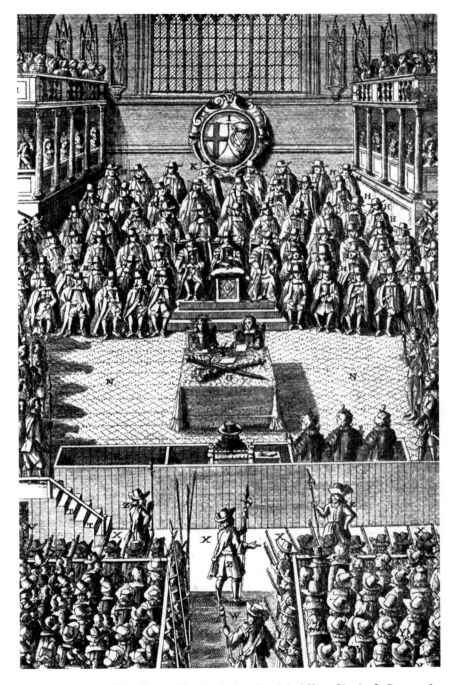

A depiction of the High Court of Justice during the trial of King Charles I. *Courtesy of Raether Library, Trinity College.*

Whalley and Goffe were 2 of 135 men invited by Cromwell to serve in that role. Many of those invited were among England's finest lawyers, judges and prominent citizens. Most of those who attended the trial were men of questionable legal background but who enjoyed a direct relationship with Cromwell. Whalley and Goffe, by now trusted confidants of Cromwell, sat as jurors in judgment of the king and could be counted on to help produce a guilty verdict. Of those invited, 47 never even appeared in the court, and many others attended only a handful of days during the two-week trial. Whalley and Goffe, in contrast, attended each day. With each passing day, the legitimacy of the trial came increasingly under question. As the tribunal was acting extra-legally, the proceedings grew clumsy and hurried. Events spiraled further and further out of control, and it became clear that obtaining a guilty verdict had begun to outweigh maintaining legitimacy as the court's priority.

On the first day of the trial, Charles stood alone and isolated in a hostile courtroom. He scanned the faces of the jury and recognized few. These people in the courtroom were not the men who had challenged his authority back in 1642. In a critique of the military tribunal, Charles

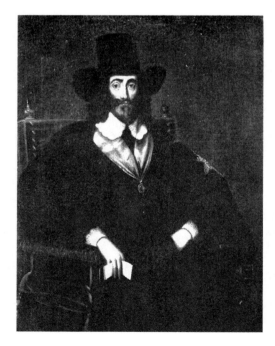

King Charles I as he appeared at his trial. Under his hat, he wore a metal helmet to protect himself from assassination. *Courtesy of Raether Library, Trinity College.*

stated in his defense, "I do stand more for the liberty of my people, than any here that come to be my pretended judges."[53] It is an ironic twist of fate that Charles condemned his accusers for breaking the English Constitution, the very charge that had been leveled against him when the war began. When asked to enter a plea, Charles denied the court's legality and refused to do so. According to English law, failure to enter a plea during a treason trial was equivalent to a guilty plea. Because Charles had refused, no evidence needed to be presented against him. This undercut the prosecution's ability to demonstrate his guilt, which further undermined the legitimacy of the tribunal. The court decided to give him three days to enter a plea. Charles stood firm.

Until the trial, Charles had demonstrated few admirable character traits. He appeared arrogant toward Parliament and the English people alike during his eleven years of personal rule and beyond. He had never been genuine in his negotiations even after military defeat in two wars. Surprisingly, Charles showed extraordinary poise and strength of character during the trial. Like his Puritan adversaries, Charles would not negotiate away what he saw as the law or his right to rule. He had been a notoriously poor public speaker, often speaking quietly and with a stammer, but by many accounts of the trial, Charles expressed himself with a clarity and resolution never before shown.

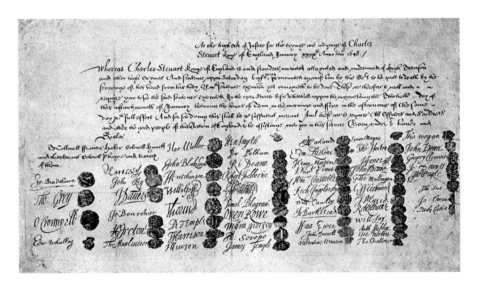

The death warrant of Charles I. Edward Whalley's signature is in the first column; William Goffe's is in the third. *Courtesy of Raether Library, Trinity College.*

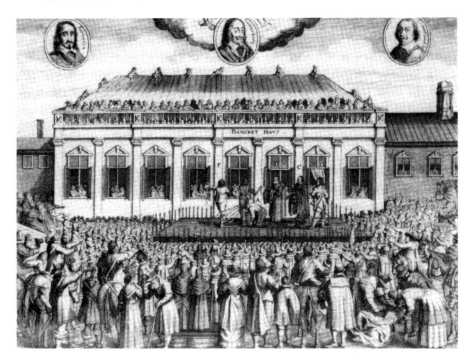

A depiction of the execution of Charles I. *Courtesy of Raether Library, Trinity College.*

He defiantly stated, "I am sworn to keep the peace, by that duty I owe to God and my country, and I will do it to the last breath of my body; and therefore ye shall do well to satisfy first God, and then the country, by what authority you do it; if you do it by an usurped authority, you cannot answer."[54] In fact, the court had no legal answer and could only proceed with the assurance that "we are satisfied with our authority."[55] Charles was pronounced guilty in a unanimous verdict by the tribunal. Both Whalley and Goffe willingly signed the death warrant. There were rumors of arm-twisting behind closed doors for some of the signers, but Whalley and Goffe's sentiments are clear: they firmly believed the king must die. The signature and seal of Edward Whalley is found fourth on the list of fifty-nine, immediately following that of Cromwell's. William Goffe's was fourteenth.

On January 30, 1649, the king walked through his banquet hall for the last time. As he walked past the soldiers who lined his way, he was spat upon and cursed. He climbed through a window onto the scaffold. A small crowd witnessed the event.

CHAPTER 7

THE PURITAN COMMONWEALTH

After Charles I's execution, Whalley and Goffe focused on consolidating the gains won through Charles I's execution. Their infant commonwealth was born in a hostile environment and needed to be defended from threats at home and abroad. Even the army was critical of its officers. During the spring of 1649, for instance, Whalley's regiment mutinied in Bishopsgate. Thirty of his soldiers outright refused his orders to leave London. They seized a local inn in Bishopsgate, London, as a base, barricading the doors. Only when Fairfax and Cromwell arrived in person did the soldiers relent. The men were swiftly and severely punished. Fifteen of the soldiers were arrested and court-martialed. Five were forced to ride the wooden horse, a punishment involving straddling a wooden horse with a peaked back, and then dismissed from service. General Fairfax sentenced another six to death, but Cromwell intervened on their behalf. In the end, only Robert Lockier, the perceived leader, was executed by firing squad to set an example for other regiments. Lockier's funeral was attended by thousands. This incident sparked other, larger mutinies in the army in the coming year.

There were also significant threats from abroad. No foreign power initially recognized the new government's legitimacy. Both Ireland and Scotland remained loyal to Charles's son, nineteen-year-old Charles II, who was planning an invasion of England to reclaim his throne. Both countries were openly hostile toward the new English government. In discussions among officers preceding the invasion of Ireland, Whalley argued that "no ill terms

be imposed upon him [the enemy], as either to eradicate the natives, or to divest them of their estates."[56] This conciliatory attitude off the battlefield was a consistent theme in Whalley's personality and career. Unfortunately, Whalley's advice was not heeded, and Ireland was brutally suppressed by his military colleagues.

Because Charles II had signed the treaty with Scotland that accepted a Presbyterian church in exchange for the crown, Cromwell correctly anticipated what would be the fourth Scottish invasion of England in only nine years. To preempt the invasion, Whalley, now promoted to the rank of commissary general, and Goffe marched to Scotland, where they were as effective as ever in their military effort. It was the beginning of a third and final civil war.

Whalley and Goffe were part of a relatively small English force of about 13,000 men that entered Scotland in pursuit of Charles II. Once there, they were eager to draw out the newly formed Scottish forces and cut them down the way they had the enemy so many times before. But Scottish general Alexander Leslie shrewdly posted his large but inexperienced army in defensive positions around Edinburgh and refused to come out. Unable to find a weakness to exploit, the New Model forces marched across the Scottish countryside for six weeks. Exposure to the harsh Scottish weather, hunger, fatigue and sickness began to take their toll on the English forces. Leslie's scorched-earth strategy left no Scottish crops or animals for the English army to seize for themselves. Provisions, therefore, had to come by sea. Exhausted and vulnerable, Whalley, Goffe and their men retreated to the port of Dunbar to restock supplies. Sensing weakness, the Scottish army abandoned its positions and seized Doon Hill, which overlooked the port. Placed in this vulnerable position, it appeared the New Model was going to have to make a hasty retreat. However, on the afternoon of September 2, the Scottish forces came down the hill to block the only land retreat route. Cromwell recognized that the Scottish forces were now overcrowded between the coast and Doon Hill, leaving themselves little room to maneuver effectively. That night, under cover of darkness and heavy rain, Cromwell redeployed his men and surprised the Scots with an attack at 4:00 a.m. under moonlight after the passing storm. Whalley's regiment was among the first to engage, charging across the Broxburn stream that divided the two sides. In the midst of the fighting, Whalley had his horse shot from under him and was wounded in the wrist and hand, yet he kept fighting. Goffe, who was leading Cromwell's personal infantry brigade of 2,500 men, also

fought gallantly. At a critical point in the battle, "at the push of the pike," Goffe and his men "repelled the stoutest regiment the enemy had there," according to Cromwell's official report.[57] In the confines of the constricted battlefield, the Scots could not mobilize their forces quickly enough, and they succumbed to the English in only two hours. The rout at Dunbar was a complete reversal of fortune and marked the greatest triumph of Whalley's and Goffe's careers. The New Model Army defeated a confident Scottish force that was more than twice its size under adverse conditions. As many as 3,000 Scots were killed and 10,000 taken prisoner. Leslie's defeat left Charles II's forces as the last remaining in Scotland.

As the New Model pursued Charles II, he led his forces south into England. Choosing a westerly route through former Royalist counties, Charles hoped to increase the size of his army with recruits before marching on London. Partly because of a parliamentary campaign against him and English dislike for the Scottish, support for the king never materialized. The roles were reversed from those at Dunbar: isolated in the city of Worcester, Charles's soldiers were surrounded by a New Model force more than twice as large as their own. Exactly one year after Dunbar, another three thousand Scots were killed and ten thousand more captured in Worcester. It was the last major military action of Whalley's and Goffe's military careers and the end of the third and final phase of the English civil war. Search parties were sent to capture Charles II, who fled into the countryside. Charles II later revealed that in his desperation he was forced to hide in the crook of a tree, since dubbed the "Royal Oak," as soldiers narrowly missed him. For forty-three days he evaded capture, hiding in secret spaces in the houses of sympathizers (called "priest holes") until he found safe passage to France in October 1652.

By this time, both Whalley and Goffe had served Cromwell well for more than seven years, and their faithful and effective service began to benefit them personally. In 1649, Goffe received an honorary master's degree from Oxford University. In 1647, Whalley had been rewarded for his service at the Battle of Worcester Commons with one of the Duke of New Castle's manors.[58] Now he accumulated more substantial estates from former Royalists. He purchased the manor of Sibthorpe, Nottinghamshire, from trustees of the earl of Devonshire's estate, as well as West Walton, Norfolk, an estate formerly owned by Queen Henrietta Maria.[59] The Rump Parliament also granted Whalley lands in Scotland worth £500 per year, and in October 1653, he purchased fenland in Cambridgeshire from a private owner. Goffe's personal fortunes

were enriched as well. In 1652, he acquired the Great Lodge and 160 acres of former Crown land in Cheshunt Park, Hertfordshire, and later purchased one-sixth of Newfoundland from Sir David Kirke.[60]

In only four and a half years, Whalley, Goffe and their New Model colleagues subjugated the entire British Isles, a conquest never before accomplished, never mind in such a short period of time. They also strengthened the navy, which tested its mettle in a brief war against the Dutch in 1652. England had not been as powerful on the international stage in more than one hundred years.[61] Having secured its status abroad, Whalley and Goffe turned their attention to domestic threats. In the wake of the glorious victory at Worcester, with the army now idle, antagonism and mistrust between Parliament and the army once again peaked. Whalley's regiment was among those most hostile to the dysfunctional body, and Whalley himself presented a petition to Cromwell calling for Parliament's dissolution.[62] Tradition holds that Parliament was secretly working on a plan to perpetuate its power indefinitely. When Cromwell learned of this, he marched with his regiment and stormed Parliament, haranguing the members for their audacity, and then expelled the members from the house permanently. Against the monarchy and against the popularly elected Parliament in the commonwealth, it appears Whalley's chosen political preference was arbitrary Puritan government.

If free parliamentary elections were to be held, army leaders were rightly afraid that conservative Presbyterians and Royalists would be elected. In place of the Rump, Cromwell and his council of officers handpicked an Assembly of Saints consisting of members screened for their friendly religious and political sympathies. This Parliament is referred to as the Barebones Parliament after one of its members, Praise-God Barbon, whose last name shared much in common with the sparsely populated body. Optimism was initially high as the 140 members took their seats, but it was short-lived. The first thing the assembly did was to declare itself a Parliament. The nominated body quickly polarized moderates and radicals. After only five months, in December 1653, the majority moderates, seeking to kill radical reform proposals, secretly met, dissolved themselves from Parliament and abdicated their authority. When about thirty radicals organized to prepare a protest, Goffe showed his disdain for Parliament by personally expelling them, leaving the Puritan rulers and England without a government once again.

CHAPTER 8
ZENITH OF POWER

Searching for any viable constitutional solution, Cromwell implemented the Instrument of Government, England's first written constitution. It included a government headed by a lord protector, a nonhereditary position held for life, chosen by a council of advisors. The single-house parliament consisted of 460 members. Voting for members was eased to include anyone whose property value was more than £200. Freedom of religion was also extended to include everyone but Catholics and extremely radical groups. Parliament was required by law to meet every three years and for at least five months at a time. After preparing eighty-two bills for Parliament to consider, ranging from highway repair to finance reform, Cromwell summoned his first Parliament under his new government called the Protectorate in September 1654.

A strong supporter of the Protectorate, Goffe sat in the 1654 Parliament for Great Yarmouth. During that meeting, Goffe was appointed to the position of "trier." Loyalty and quality of the clergy was important to Cromwell, as it had been to Charles before him, and triers vetted new candidates for the clergy. Whalley represented Nottinghamshire in the same Parliament. Despite the presence of loyal members like Whalley and Goffe, the elected Parliament once again turned against Cromwell. It created a committee to review and dissect every clause of the Instrument, scrutinizing its legality. Most of the body's legislation was geared toward undermining the newly created constitution. Clearly, the English people did not appreciate Cromwell's arbitrary rule any more than they had Charles's. Like Charles

before him, Cromwell could not control his Parliament. After nearly five months, the shortest time allowable, without having passed a single one of his proposals, Cromwell dissolved Parliament in January 1655.

That spring, it became clear that Royalists were conspiring to undermine the Protectorate government. These efforts culminated in a military rebellion called Penruddock's Uprising in Wiltshire. Goffe was part of the forces sent to crush the rebellion. Although the uprising was easily suppressed, the civil unrest in the countryside forced Cromwell to resort to direct military rule. He divided England into eleven districts, called associations, and placed a major general in each, charging the generals with the massive responsibility of keeping the peace. Whalley and Goffe were two of the major generals assigned to associations. Both were placed in the regions of England in which they were purportedly raised: Goffe in Berkshire, Sussex and Hampshire Counties and Whalley in Lincoln, Nottingham, Derby, Warwick and Leicester Counties.

As a group, the major generals were despised. They were viewed as unelected military intruders who arbitrarily imposed their puritanical values, a heavy tax and rule without consideration of localities. Many generals lived up to these accusations. One major general, Thomas Pride, said he ended bearbaiting in his association, "not because it gave pain to the bears, but because it gave pleasure to the spectators."[63] Although only seventeen months in duration, the rule of the major generals was a poignant symbol of the military nature of life in England under Puritan rule.[64]

To this point in their careers, Whalley and Goffe had been staunchly loyal to Cromwell, but their service only extended to the battlefield. The rule of the major generals marks their first opportunity to serve as civilian magistrates. According to historian Christopher Durstan, "As staunch Puritans, a strong commitment to the concept of the godly society was at the very core of their collective religious vision, and they saw their appointments as a literally heaven-sent opportunity to suppress wickedness and create…'an ordered and godly commonwealth.'"[65] The generals had many responsibilities, all what one might expect from a Puritan government. First and foremost, they had to disarm anyone who threatened their rule. Once stability was achieved, the major generals were also assigned to relieve the poor and imprison the idle.[66] They were also instructed to "encourage and promote godliness and virtue" according to Puritan values.[67] Public swearing was punished, drunkenness was outlawed and gambling was banned under their authority. To pay for the enforcement of these laws, the decimation tax of

10 percent was levied on former Royalists, the collection of which took up much of the major generals' time. Whalley and Goffe enthusiastically served and quickly got to work.

While Whalley took his responsibilities seriously, his style was among the most moderate of all the major generals. According to his report, Whalley quickly "set the wheels agoing" by touring the four counties of his association for several months and setting up the assessments and collection of the decimation tax on Royalists.[68] His assessment was bleak. Unlicensed alehouses were commonplace, and efforts at reform were inconsistently applied. "What some justices in order to reformation do, others undoe," Whalley complained in a letter written to Secretary of State John Thurloe early in his tenure. Whalley took his responsibility for moral reformation seriously and set to work. He cooperated with civilian magistrates to promote godly men and moral behavior.[69]

So industrious was Whalley against vagrancy that he filled his jails to capacity. He proudly reported, "This I may truly say, you may ride over all Nottinghamshire and not see a beggar or wandering rogue, and I hope suddenly to have it so in all the counties."[70] To ease the overcrowding and the financial burden of incarceration, Whalley persistently called on the government to create a plan for prisoner deportation. "Horse-stealers, robbers and other condemned rogues lie in the jails. To continue them there is a charge to the country; to give them liberty there is to make more; and your this long forbearing them without sending them beyond seas, I fear hath increased their number, to the dissatisfaction of the country... The clearing of jails and countries of rogues would be very pleasing to them," he reported to Thurloe in 1656.[71] In August 1656, the council created the Jamaica Committee to take action on this task. One thousand of the prisoners were to be selected for military service in Sweden, with the remainder to be sent to North America or the Caribbean. Before this could be carried out, however, parliamentary election season arrived, distracting many major generals from the plan.[72]

Vigilant against vagrancy, Whalley was also the only major general to dedicate himself toward easing the burdens of the poor. The enclosure movement was a major transformative social movement in England during the entirety of the seventeenth century. Characterized by the enclosure, or privatization, of common grazing, pasture and agricultural lands, it led to large amounts of unemployment and depopulation among the lower classes. Whalley conducted a survey to document the effects of enclosure

in Leicestershire and later that year instituted an ordinance to remedy the problem, requiring the interested parties to pay a bond to ensure its success. "Upon these terms I hope God will not be provoked, the poor not wronged, depopulation prevented, and the state not damnified," Whalley wrote in his report.[73] He even went beyond local reform and introduced an enclosure bill in Parliament later that year. Whalley was likewise concerned about unfair business practices that he observed in his counties. At markets, customers were being shortchanged by vendors and overcharged for services. Whalley advocated for a national standard of weights and measures to help reduce such profiteering.[74] He also recommended that markets open earlier in the morning so that countrymen would not have to sell at low rates in the evening.[75]

Considering his extreme commitment to Puritanism and to Cromwell, Whalley demonstrated an admirable restraint and sensitivity to citizens of all backgrounds. Unlike other major generals who were maligned for their austerity measures, Whalley allowed Lady Grantham's Cup, a horse race in Lincoln, to continue to be run. In response to the Earl of Exeter's request to host the event, Whalley explained, "It was not your highness's intention in the suppressing of horse races to abridge gentlemen of that sport."[76]

In matters of religion, Whalley again showed a preference for conciliatory policy. In December 1655, he was in favor of readmitting Jews into England, writing, "I am glad so godly and prudent a course is taken concerning the Jews, yet cannot conceive the reason why so great variety of opinion should be amongst men as I hear are called to consult about them." Whalley was not threatened by the presence of Jews in English society; instead, he felt that their integration would provide economic gains and an opportunity to convert them to Christianity.[77]

In the autumn of 1656, a religious crisis occurred in Bristol, England, when Quaker leader James Naylor reenacted Christ's arrival in Jerusalem. Naylor, who bore a strong physical resemblance to Jesus, had just been released from prison and was traveling with a small group of Quakers to Bristol. Naylor was on horseback, while the others laid down garments in his path. The act was considered blasphemous and interpreted as Naylor's suggesting that he was Jesus. During the parliamentary debates later in the year, Whalley believed Naylor to be guilty but once again demonstrated a cool head during a passionate time. He suggested that "those that are for a low punishment might not be censured for coldness, nor those for a higher punishment censured for a preposterous zeal."[78] This sentiment is a testament to the moderation Whalley revealed in his personality on a consistent basis.

Whalley was ultimately one of four major generals to support execution for Naylor, with the condition that Naylor be spared if he recanted.

In his private life, Whalley's year as a major general was a struggle. Whalley shared two sons, Henry and Edward, with his second wife, Mary Middleton. During much of this time, she was sick as she made a slow recovery from a miscarriage suffered in July.[79] Professionally, Whalley was at the peak of his career and demonstrated a knack for civilian leadership. He was pleased with the effectiveness of his policies and showed a genuine interest in creating a civil society. He was a strong supporter of the Rule of the Major Generals, which he considered "the best way that ever was devised for the peace and safety of the nation."[80] "Our presence I find is desired in all places and gives life to all proceedings; besides they look upon it as a favor to them to have us in their county. You cannot imagine what an awe it hath struck into the spirits of wicked men, what encouragement it is to the godly," Whalley reported.[81]

Goffe did not share Whalley's optimism or confidence. He approached his new position with humility and caution. He expressed the hope that Cromwell would not regret putting his trust in "so poor and inconsiderable a creature."[82] He had reason to be wary. Goffe embraced the opportunity with alacrity similar to Whalley's but seemed to face more substantial obstacles in his association. Goffe's fiscal challenges were more formidable than Whalley's. From the beginning, Goffe was bogged down in financial hardship that dominated much of his time. His share of the assessment from the decimation tax was less than half of what was required to maintain his militia. He was forced to spend much of his time trying to maximize the tax and finding supplementary sources of revenue. Goffe worried that much of the blame for the shortfall would fall on his shoulders: "If the work and ourselves perish for want of our wages, it will not, I hope, be laid to our charge"[83]

Goffe routinely maintained a hard stance toward religious radicals. When Quaker leader George Fox arrived in Sussex, Goffe threatened to "lay Foxe and his companions by the heels if I see good opportunity."[84] Goffe was equally aggressive in the Naylor crisis. He argued that Naylor was a false Christ and felt that Quakers were "doing much work for the devil and deluding many simple souls" while deceiving the godly. Goffe vigorously supported Naylor's execution.[85] Naylor was ultimately spared death, though he was cruelly tortured and suffered permanent disfigurement.

This was not an easy time for Goffe. Aside from his financial challenges and substantial political opposition, Goffe was distracted by the trouble his

wife was having adjusting to his family's relocation to a house in Winchester. In many of Goffe's letters, he expressed frustration at the slow pace of change, and he found the heavy workload to be exhausting. In one letter, he expressed that he could hardly find the energy to write.[86]

With many generals sharing Goffe's financial woes, they pressed Cromwell to call another Parliament in the hopes of securing a more stable form of funding. They were hopeful that the elections would yield members sympathetic to their cause. Their chances were increased since the Council of State retained, and actively used, the power to exclude individuals from serving. Since there was no coordinated national strategy, each major general worked individually on behalf of the candidates he supported.[87] Goffe faced substantial opposition among the populace of his association and spent a lot of time and effort on the election. In the county of Hampshire, he disapproved of the slate of candidates, which included Royalists, and he recommended that Richard Cromwell, Oliver's son, along with a local landowner, draw up another slate that could win.[88] In Sussex, Herbert Morley sought to seize upon anti-government sympathies by campaigning against Goffe, the army and any man paid by the Protectorate government. Goffe was not to be discouraged. "However proud men deal perversely with us without a cause, yet they may at last be ashamed and, our hearts being kept sound in all the ways of truth and holiness, we may not be ashamed," he wrote.[89] So formidable were his adversaries that Goffe, relieved by his ultimate electoral victory, reported, "Considering the great efforts made to stop me being elected and the unkindness of some I had expected better from," he looked upon his election "as a special providence of God."[90] The election did not turn out as well in Sussex, where less supportive candidates were elected.[91] On balance, however, Goffe was satisfied with the results, "though they be not so good as we could have wished them, yet they be not so bad as our enemies would have had them."[92] Even so, the council excluded twenty-nine elected members, out of a possible seventy-five from Goffe's and Whalley's associations, from taking their seats in Parliament.[93]

Despite the generals' efforts and the exclusion of hostile candidates, opposition to the major generals remained great. When General John Desborough introduced a bill to make the decimation tax permanent, a bill that both Whalley and Goffe supported, it was soundly defeated, effectively ending that taxation system. Although only in existence for little more than a year and largely ineffective, the rule of the major generals was a powerful symbol of arbitrary rule of the sword for critics of the Cromwell regime.[94]

Cromwell himself made little effort to save the system, and the major generals deeply resented him for that. In the midst of this debate, a small group of influential politicians sought to replace the major generals with a more traditional form of government that was more acceptable to the populace.[95] The "Humble Petition and Advice" was a return to England's three-part Parliament. It included the House of Commons, the "other House" (formerly the House of Lords) and the return of the monarchy. In the spring of 1657, Cromwell was seriously considering accepting the crown; he was, after all, a king in all but name already. However, vehement opposition to monarchy among his major generals, including Whalley and Goffe, caused him to pause and reconsider.

That March, Cromwell met personally with the major generals and other officers. He began his speech by defending himself against charges that he was seeking the crown, saying he had not sought the crown but rather the title was a "feather in a hat" that "he loved…as little as they did." He then expressed frustration with his officers, explaining that he had bowed to their pressure too many times in the previous five years and that while they had served him well, "it is time to come to a settlement and lay aside arbitrary proceedings, so unacceptable to the nation."[96]

As time progressed, both Whalley and Goffe warmed to the possibility of Cromwell's becoming monarch. That April, when the house voted to offer the crown to Cromwell for the first time, Whalley, as teller of the noes, tabulated the votes for those against the offer. However, a report from later in the month suggests that Whalley and Goffe could be won over, and on April 24, 1657, Whalley admitted that he could "swallow that of the title."[97] Ultimately, Cromwell chose to side with his military power base and remain as lord protector. He later appointed both Whalley and Goffe as members of the upper house of Parliament, sometimes referred to as Cromwell's House of Lords.

Their tenure was short-lived. In September 1658, Whalley and Goffe were called to Cromwell's bedside. They were among the seven men chosen to hear Cromwell proclaim his son Richard his successor. Cromwell's years on the battlefields of England, Scotland and Ireland had caught up with him. Whalley and Goffe's exemplary service to Cromwell had been the source of his power on and off the battlefield. They had earned his trust, and he, in turn, had become their greatest benefactor. Through their service, they rose from obscurity to conquer and execute a tyrannical king and create a new government, all in the name of God. At sixty-one years old, on the anniversary of their triumphant victories at Dunbar and Worcester, Oliver Cromwell was dead.

CHAPTER 9
ESCAPE TO NEW ENGLAND

Oliver Cromwell's death drastically changed the political landscape in England, and without their champion, Whalley and Goffe struggled to hold on to power. They remained loyal to Richard, whom Oliver named his successor. But Cromwell had never been able to resolve the constitutional crisis that had started that country's civil war, and there was never an established way to hand power to his successor. Cromwell's power rested in the strength of his personality, military brilliance and political acumen. His son Richard possessed none of these character traits. The power transfer was initially remarkably smooth, but it quickly became clear that Richard did not, nor did he really wish to, possess the ability to rein in the factions that his father had so capably kept at bay. Richard's retirement in July 1659 left Whalley and Goffe without a national figure to rally behind, making them vulnerable to the unpredictable political currents in the wake of Cromwell's death.

After Richard Cromwell dissolved his one and only Parliament, chaos ensued. England experienced no fewer than seven governments in the course of a single year. One of the Parliaments relieved Whalley of his command for fear that his troops would be more loyal to him than to Parliament, as had been the case so many times for Cromwell. As the political struggles continued, it became clear, once again, that the situation would only be settled through the force of an army. It was the army in Scotland, under the stable command of General George Monk, that was strong enough to enforce its will. The consummate professional, Monk kept his small force well paid and

well trained, a model for success. In November 1659, the army in England sent Whalley and Goffe, as part of a four-man delegation, to Scotland with the hope of convincing Monk to back a republican government. Monk already knew of Whalley (they had served together in the Battle of Dunbar), but Monk refused to even meet with them. He knew their intentions did not align with his own, which was to restore Charles II to the throne. On January 1, 1660, Monk marched his small but strong army into England and seized London with remarkable ease. Monk recalled the remnants of the old Long Parliament, the last legitimately elected Parliament; that body, in turn, called for new elections before quickly dissolving itself. There was little doubt that the new Parliament would be dominated by loyalists.

Desperate to seize upon this opportunity in this fluid political atmosphere, on April 4, 1660, Charles II issued the Declaration of Breda, in which he offered a "free and general pardon" to any enemies of his father during the civil war or Protectorate, excluding only "such persons as shall hereafter be excepted by parliament." Charles II was not a particularly vengeful person; however, he always harbored resentment toward the men who had illegally tried and executed his father. He knew he could count on the newly elected loyalist Parliament, which was far more punitive and vengeful than he, to seek out and prosecute his father's judges. In the wave of loyalist sentiment that swept over the nation, Whalley, Goffe and the other men who had served central roles in the Cromwellian regime needed to prepare for the worst.

The urgency of the moment forced Whalley and Goffe to make some difficult and bold decisions. They were correct in their assessment that Charles II was to be restored in a matter of days or weeks. They also correctly assumed that their close ties to the tribunal that convicted Charles I made them prime targets of the Royalist wrath that dominated the newly elected Parliament. Of course, by this time, many of the prominent men of that illegal tribunal had passed away naturally in the eleven years since the execution. Of the original fifty-nine men who signed Charles I's death warrant, only forty-one remained alive. For those surviving, options were few and not particularly attractive. Remaining in England was simply dangerous. For the immediate future, hope of a Puritan uprising was nonexistent. To try to remain in hiding within the country would be difficult, and if caught, they would face certain trial for the murder of the late monarch. The penalty for that crime—the crime of treason—was barbaric. Traitors were to be hanged, drawn and quartered. Despite this gruesome prospect, the majority of the surviving regicides chose to remain in England and face this dreadful end.

Others chose to flee for their lives and wait for a better opportunity to return England to a Puritan rule, but where to go? Fifteen of the judges, the regicides, as the king's judges and others associated with the trial came to be called, chose this option. ("Regis" translates to "of king" and "cida" to "killer.") Of the twenty, seventeen chose the European continent, with Holland, Germany and Switzerland being the three friendliest and most common destinations.[98] Of course, they would need to be mindful of the king's agents abroad, but if they kept a low profile, Whalley and Goffe and the other regicides could maintain a relatively high quality of life in these countries. They would be able to keep their identities, practice their religion freely (although in the minority), maintain frequent communication with their families and be updated of the day's events.

Another option was to make the transatlantic voyage to the Puritan colonies of colonial New England. The prospect of being surrounded by fellow Puritans, each equally as passionate about their Puritan cause, made this an attractive alternative to moving to the European continent. As regicide historian Philip Major notes, "For puritans like Whalley and Goffe, looking west from Old England, this community was a saving remnant keeping alive a puritan theocracy that had collapsed on their side of the Atlantic."[99] New England's Puritan founders chose colonization as their manifestation of resistance to Charles I's religious policies and persecution, and they would certainly be sympathetic to the two colonels who had fought for the cause in England. New England was populated largely by the congregants of leading Puritan theologians who had made the trip over. Many of these men and women had already spent years in Europe after fleeing for their lives in England. John Davenport, a leading minister in New Haven, was forced into exile in 1633 by the hated Archbishop William Laud. Oliver Cromwell and John Hampton had each strongly considered emigration themselves several times during the dark years preceding the war.[100] Tensions were so high during the 1630s that a group of Puritan lords, desperate for a refuge, pooled their money to establish new colonies to which they could flee if England could not be saved. Their first attempt, Providence Island, in the Caribbean, suffered setback after setback before being conquered by the Spanish. Later, in 1634, they commissioned Lion Gardiner to build a fort at the mouth of the Connecticut River, called Saybrook after two of the leading financiers. Once complete, Gardiner was directed to begin building houses suitable for lords and gentlemen. Only one, Lord Fenwick, ever actually came over before the Puritan victory in the civil wars made the small colony unnecessary. In

1639, Saybrook voluntarily merged with the colony of Connecticut, which was located farther up the Connecticut River. During this period, a charter granted by the king was required to establish a colony. Massachusetts and Connecticut successfully obtained their charters, but Rhode Island and New Haven were founded illegally. In the 1630s, during the personal reign of Charles I, these colonies were satisfied to remain without charters rather than submit to the tyrannical king.[101]

Although essentially all New Englanders were proud of their English heritage, loyalty to the English king was far less uniform. Four years after Boston was founded, for example, rumors abounded that Charles I determined to send a royally appointed governor to Massachusetts Bay. If a royally appointed governor did arrive, at least one group of ministers advised the magistrates that they should not accept the new governor and that they should "defend our lawful possessions if we were able." Two years later, another controversy arose when some English ship captains complained that the English flag was not being flown in the harbor. When they learned there was not a flag available to hang, the men offered to lend one. After a day's deliberation, a compromise was struck, and the flag was allowed to be flown over the fort in the harbor with the understanding that the flag represented the king's authority over the fort but not the colony.[102]

Not surprisingly, New Englanders were ardent supporters of the parliamentary side during the civil war. Once the war began, New England experienced a reverse migration, in which many families traveled back to England to fight against the king.[103] In May 1643, before the outcome of the war was certain, the Massachusetts government removed the king's name from the oath of allegiance to which men agreed in order to become freemen of the colony. Similarly, the king's name disappeared from the oath taken by the governor and his elected assistants.[104] When, in 1644, "some malignant spirits began to stir, and declare themselves for the king," the General Court passed an order prohibiting any demonstration of support for the Royalist cause by action, word or writing.[105]

For those who stayed behind in New England, prayer was a very real and powerful weapon. Connecticut and New Hampshire held monthly days of fast and prayer. New England clergy were leading Puritan theologians. As such, New England ministers Cotton Mather (Massachusetts), John Davenport (New Haven) and Thomas Hooker (Connecticut) offered advice and defense of the Puritan position.[106] Surely, these influential New England leaders would be willing to harbor such distinguished guests as Whalley and Goffe.

The New England colonies were home to many who had personal ties to either Cromwell or his cause. Disciples of John Cotton, Thomas Goodwin and John Owen were Cromwell's closest religious advisors. Jane Hooke was Edward Whalley's sister and Oliver Cromwell's cousin. Jane was married to William Hooke, who was the minister of New Haven before moving back to England after the war, where he became the Cromwell family chaplain.[107] John Winthrop Jr., governor of Connecticut, was a good friend of Hooke's.[108] Also of New Haven was William Jones, who was distantly related to Whalley. Jones's father, Colonel John Jones, was a judge against the king and was being prosecuted back in England.[109] These personal connections with so many of New England's leading men could surely prove invaluable.

As a result of their shared religious orthodoxy and dedicated support to the parliamentary cause, the New England colonies enjoyed the fruits of Puritan rule under Cromwell. During the war in 1644, the Bible Commonwealths of New England successfully won exemption from import and export duties from Parliament. After Cromwell's victory at Dunbar, he had sent a large number of the captured Scots to New England to help ease the labor shortage. During the Protectorate, Massachusetts, Rhode Island and New Haven each sought closer relations with Cromwell's Puritan regime (unlike other colonies such as Virginia), and Cromwell frequently responded in kind. During the Dutch War in 1652, New Haven petitioned Cromwell for protection from the Dutch in New Amsterdam; Cromwell provided four ships, though peace between the two nations was achieved before action could be taken. Whalley and Goffe would have been very aware of the cozy political, religious and political relationship shared between the Old World and New and would be able to exploit its value.[110]

Hiding in New England posed difficulties, too. The primary problem was that the area was within the British realm. Unlike in foreign lands, anyone in New England caught helping the regicides was guilty of treason. The hosts who sheltered and protected them were putting their lives in serious danger. While some New Englanders were certain to act against Whalley and Goffe out of loyalty to the Crown, the risk of appearing complicit would largely deter neutral colonists from acting on their behalf. Conversely, the promise of a hefty reward and possibly the awarding of a title of nobility might sway otherwise disinterested parties to act against the fugitives. Thus, even though New England was a promising refuge, living there might prove more complicated than Whalley and Goffe initially may have thought.

Escape to New England

With Charles II's restoration imminent, a decision needed to be made. On May 4, 1660, Charles II's Declaration of Breda was read in Parliament. Three days earlier, on May 1, Charles boarded the English ship *Naseby*, which he rechristened the *Royal Charles*, from the Netherlands bound for Dover, England, where he would arrive shortly. Whalley and Goffe did not wait for further events to transpire. On May 12, under the aliases of Richardson and Stephenson, Whalley and Goffe boarded the ship *Prudent Mary* at Gravesend, England, bound for Boston, Massachusetts. On the very day that their ship embarked, the House of Commons issued orders for the arrest of "all those persons who sat in judgment upon the late king's majesty when sentence was pronounced."[111]

Little is known of the physical conditions of their voyage, but Whalley and Goffe were in good company on the ship. They were joined by Daniel Gookin, an influential assistant in the Massachusetts government, and William Jones, a New Haven magistrate.[112] Whalley and Goffe would be nearly helpless in the colonies without influential and sympathetic contacts, and they were off to a promising start. Early in the voyage, only three days in, news of Charles II's restoration reached their boat. Whalley and Goffe must have wondered what God's fate held for them in the New World and for the colleagues they were leaving behind in the Old.

CHAPTER 10

HEROES' WELCOME

C harles II, Whalley and Goffe each received a gracious welcome upon arrival to their respective new homes. Charles arrived in Dover on May 25 and was greeted with throngs of celebrating Englishmen all along his journey to London. Once there, Charles was presented with his army, the former New Model, which still contained some of the very men who had toppled his father's forces. On June 6, Charles summoned Whalley and Goffe, along with the other regicides, to appear before him within a fortnight or forfeit any chance of pardon.[113]

When Edward Whalley and William Goffe arrived in Boston on July 27, 1660, they brought with them the news of Charles II's restoration to the throne of England. This turn of events had important, even dire, ramifications for the New England colonies. Unlike other colonies in North America, the New England colonies were founded by religious refugees seeking distance from the Crown. During their infant years, Charles I was too weak to enforce his prerogative on the colonies across the ocean. As a result, some colonies, such as Plymouth, Connecticut, Old Saybrook and New Haven, were founded without charters from the Crown and were acting with virtual autonomy. Massachusetts possessed a very liberal charter that established a government with essentially no royal influence. With the restoration of Charles II, the status of Massachusetts's charter was called into question. For the rest of New England, existence as separate colonies could quite possibly come to an end. Each colony needed to determine its best course of action. The colonies needed to decide if they should proclaim their loyalty for the king

or assert their independence. If they proclaimed their loyalty, they risked losing their prized autonomy from royal prerogative. Yet the North Atlantic coast in 1660 was a world of growing competition between the English, Dutch and French forces. If the colonies tried to become an independent commonwealth, an option many seriously considered, invasion by their neighbors was likely.[114] The colonial trade with England was also of growing importance to the young American economies. Clearly, the risks of breaking completely free of England were too great, and the colonies needed to stay within the English empire. The challenge was how to benefit from that arrangement while sacrificing as little autonomy as possible.[115]

This circumstance made hosting the killers of the king's father far more complicated. Upon their arrival in Boston, Whalley and Goffe were initially greeted with a hero's welcome. These men were two of the most celebrated of God's soldiers, high-level officials with close ties to Oliver Cromwell himself. They were the most prominent Englishmen yet to visit New England, and Bostonians treated them as such.[116] Once off the boat, Whalley and Goffe immediately met with Massachusetts governor John Endecott, who welcomed them warmly.[117] Although far from their families and uncertain of their future, the exiles must have found joy in their new life in Boston. They were thousands of miles removed from the political tumult of England and enjoyed living openly, and in some ways lavishly, in their new surrounds. Colonial state papers report that they were held in "exceeding great esteem for their piety…and were looked upon as men dropped down from heaven."[118] It was brazen for Whalley and Goffe to live so openly in colonial society, making no attempt to conceal their identities, and it was a decision they might later have regretted. News of their arrival spread quickly beyond Massachusetts and throughout New England. On August 11, New Haven reverend John Davenport wrote a letter to Connecticut governor John Winthrop Jr. in Hartford. Endecott explained that he had learned that two gentlemen of great quality, Whalley and Goffe, had arrived in Massachusetts Bay. Having been a colleague of William Hooke, Davenport knew of Whalley and Goffe as well. He told Winthrop that he knew of their narrow escape from England and that he was eager to host them as soon as possible.[119]

While in Massachusetts, Whalley and Goffe stayed in the house of their new friend, Daniel Gookin, whom they had met on their eleven-week voyage across the Atlantic. The location of Gookin's house, across the Charles River in Cambridge, may have been chosen as their first lodging for its relative inaccessibility as compared with Boston.

While in Cambridge, Whalley and Goffe attended church services and met many of the principal people of the colony. They attended a lecture and church service led by John Norton, after which they "were lovingly entertained, with many ministers, and found great respects from them."[120] John Crown, a Harvard student who was boarding with Norton, reported that he frequently heard Whalley say that if presented with the opportunity to try to execute the king again, he would do it.[121] Several others had heard Whalley make the same boast. The Reverend Charles Chauncey, president of Harvard College, hosted the exiles at his house, where he expressed his thoughts that God had brought them there "for good both to them and ourselves." After visiting Chauncey, Whalley and Goffe were provided guides and horses with which to tour towns throughout the countryside. Goffe spent the night with a man named Elder Frost. Of the visit to Frost's humble home, Goffe wrote, "A glorious Saint makes a mean cottage a stately palace; were I to make my choice, I would rather abide with this Saint in his poor cottage than with any one of the princes that I know of at this day in the world."[122]

In the late eighteenth century, Ezra Stiles, historian and president of Yale College, took a special interest in the regicides. Investigating their story about 120 years after it took place, Stiles went beyond the traditional use of documentary evidence and relied heavily on the oral traditions surrounding these men. Stiles recorded many legends passed down from generation to generation by members of those families who had aided Whalley and Goffe. Predictably, the validity of each of these stories varies; some are simply unverifiable. In his notes, Stiles relates an amusing legend that, if even partially true, reveals something of the men or the times in which they lived. When William Goffe was in Boston, a man arrived in town and set up a stage. The "fencing master" audaciously challenged any man to beat him "at swords." Goffe, apparently up for some fun, dressed himself in rustic clothes and armed himself with a mop. For defense, he wrapped a wheel of cheese in a napkin to use as a shield. Before stepping onto the stage, he dipped the mop end into a mud puddle. The fencing master could not take his ludicrous challenger seriously and told Goffe to leave. But when Goffe refused, the man came at Goffe hard with his sword. Goffe, the highly accomplished veteran military officer, moved quickly and caught the sword in his cheese, held it there and countered by rubbing his wet mop over the man's mouth, making the appearance of whiskers with the mud. Apparently having freed his sword, the man again charged Goffe, only this time Goffe rubbed the mop head over his eyes. The crowd must surely have enjoyed the outrageous

sight. The third time, Goffe mopped the man's entire face. When the man reached for an actual broadsword, in place of the smaller fencing sword, Goffe warned, "Stop sir! Hitherto you see I have only played with you, and not attempted to hurt you; but if you come at me now with the broad-sword, know, that I will certainly take your life." To which the man replied, "Who can you be?" Perhaps knowing that Whalley and Goffe were in Boston at the time, the man continued, "You are either Goffe, Whalley, or the Devil, for there was no other man in England that could beat me." At that point, Goffe left the stage and disappeared among the crowd and laughter. Stiles writes that it was at one time common to speak of a great athlete by saying none could beat him but Goffe, Whalley or the devil.[123]

Not all of Whalley and Goffe's interactions were positive. However, when they were threatened, Massachusetts men were quick to come to their defense. Captain Thomas Breedon, a noted Royalist, initially identified Whalley and Goffe to Governor Endecott as traitors who should be immediately arrested. Governor Endecott simply dismissed his suggestion, replying, "None should meddle with them."[124] Breedon complained of Endecott's recalcitrance and also of abuse he had suffered at the hands of other Massachusetts residents. In one instance, while in court, the marshal general of the colony had challenged Breedon directly, grinning as he spoke and threatening, "Speak against Whalley and Goffe, if you dare, if you dare, if you dare!"[125] Incensed, Breedon described these experiences in a report informing officials in England of Massachusetts's warm welcome to Whalley and Goffe. Events such as these were preserved in official affidavits made by Breedon and others to officials in London as proof of the disloyalty of Massachusetts colony.[126]

As the fall of 1660 progressed, more foreboding news arrived from abroad. In late November, people in the colonies learned that Parliament had passed the Act of Indemnity. The act, which had actually been passed months earlier, on August 29, 1660, granted official forgiveness to all who previously swore allegiance to the commonwealth and Protectorate. However, an exception was made for those who directly participated in the execution of Charles I, and Whalley and Goffe were listed by name. On September 22, a royal proclamation was issued offering a reward of £100 each for the apprehension of Whalley and Goffe, whether captured dead or alive.

What's more, Charles and Parliament were moving swiftly in England against many of Whalley and Goffe's former colleagues. In October, twenty-nine regicides were tried and found guilty in London. On Thursday, October

11, Thomas Harrison was the first to be tried. Harrison stated that he had acted by the authority of Parliament, but the jury found him guilty without deliberation. The judges' sentence read as follows:

> *The judgment of this court is, and the court doth award, that you be led to the place from whence you came, and from thence to be drawn upon an hurdle to the place of execution; and there you shall be hanged by the neck, and being alive shall be cut down, and your privy members to be cut off, you entrails to be taken out of your body, and, you living, the same to be burnt before your eyes, and your head to be cut off, your body to be divided into four quarters, and head and quarters to be disposed of at the pleasure of the king's majesty, and the Lord have mercy upon your soul.*

The following day, four others were also found guilty and similarly sentenced.[127]

As an added touch, when John Cook was dragged to the scaffold, the head of his friend Thomas Harrison was placed on the same hurdle, with his face looking at him. Cook was then quartered in front of fellow Puritan Hugh Peters. When the executioner, rubbing his bloody hands together, asked how he liked what he saw, Peters replied that he was not terrified and that the executioner might do his worst. When on the ladder, Peters said to the sheriff, "Sir, you have butchered one of the servants of God before my eyes, and have forced me to see it in order to terrify and discourage me; but God has permitted it for my support and encouragement."[128] The neighborhood of Charing Cross, where the executions took place, was chosen for its view of the banqueting house of Whitehall, where the king had been executed. However, after nine of these executions, residents petitioned the king not to stage any more executions there because of the stench of the burnt bowels. Two more executions were then conducted at Tyburn, the traditional location for executions.

After ten executions, Charles postponed the remaining nineteen. Not a very vindictive man, he ordered that their sentences first be suspended and then commuted to life imprisonment. Charles, who could not bring himself to pardon those who had murdered his father, wrote, "I must confess I am weary of hanging except upon new offenses." But the deaths did not come to a full end. In 1662, three regicides—John Okey, John Barkstead and Miles Corbet—were discovered hiding in Holland and brought back to England, tried and executed. Another regicide, Edmund Ludlow, returned to London

as late as 1689 after decades of living in Switzerland, expecting to live without censure, only to find a proclamation and reward issued for his arrest. Ludlow escaped and lived the remainder of his life in Vivey.[129]

If Whalley and Goffe had chosen to remain in England after Charles II was restored to the throne, they would have faced certain trial and a guilty verdict. It is difficult to say whether they would have been among those the king and Parliament sought to make an example of through execution. Judging by the issuing of the royal proclamation for their seizure and by the fates of their regicide brethren who were captured abroad (Okey, Barkstead and Corbet), it is likely that if Whalley and Goffe were apprehended in New England in the short or long term, their execution would have been nearly certain.

In December 1661, Parliament passed a resolution ordering the bodies of Oliver Cromwell, John Bradshaw and Henry Ireton to be exhumed from their graves in Westminster Abbey.[130] Their bodies, already in an advanced state of decomposition, swung from the gallows at Tyburn Hill in the cold January air. Cromwell's head (or what was thought to be) sat on a pike in front of the Tower of London for more than twenty years.

These events in London raised alarm in Boston. The king and Parliament were serious about their prosecution of the regicides. Boston's aid to Whalley and Goffe meant dangerous consequences for individuals and the colony alike. With the king's position clear, Massachusetts could no longer flout the law. Loyalists in the General Court, a clear minority, recommended the immediate arrest of Whalley and Goffe, which they believed to be not only the just but also the legal course of action. The swift arrest of Whalley and Goffe would also be a testament to the loyalty of the colony and undoubtedly would be a significant gesture toward a warming of relations between Crown and colony. On a more personal level, the loyalists, who were mostly merchants, may have hoped that loyalty would be rewarded with lucrative trade opportunities.

Opposite the Royalists was the Commonwealth faction. Drawing from a broader base of the population, including farmers, clergymen and artisans, and with members such as Governor John Endecott, Deputy Governor Richard Bellingham and the aforementioned Daniel Gookin, the Commonwealth faction was more influential than the loyalists. This group contended that its lenient charter, granted by Charles I, made Massachusetts Bay a virtually autonomous commonwealth. These men enjoyed life out of Charles I's reach before his execution and a preferred status during the interregnum. Now, with the monarchy restored, the

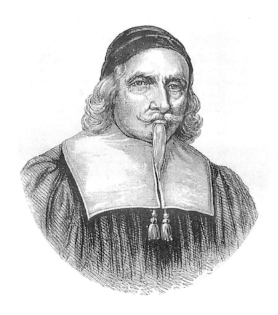

Massachusetts governor John Endecott. *Courtesy of Yale Art Gallery.*

Commonwealth faction sought to remain as autonomous as possible. In between, and representing the largest opposition to the Commonwealth faction, were moderates who sought to pursue Massachusetts's goals while remaining within the British Empire.[131]

In October, before receiving much of the aforementioned news from London, the moderates had called for Whalley's and Goffe's arrests. Because news of the king's proclamation had not reached America, Massachusetts was technically not doing anything wrong. Whalley and Goffe were not officially recognized as fugitives because the news that they had been declared such had not reached America yet. Governor Endecott simply dismissed those calls for arrest.[132] In November 1660, news arrived of Whalley's and Goffe's exemption from the Act of Indemnity (issued on August 29 in England), which forced colonial leaders to make an official decision concerning the colonels. On February 22, 1661, Governor Endecott summoned the Court of Assistance to decide the fate of these men. While the court considered its options, Whalley and Goffe easily stayed informed of the deliberations because they were still living with Daniel Gookin, who was present at the meetings.[133]

CHAPTER 11
JUDGES CAVE

There was too much at risk for Massachusetts to continue harboring the regicides, and it was clear that Whalley and Goffe's sympathizers in the government could now only delay their arrest rather than prevent it. Whalley and Goffe secretly slipped out of Cambridge on February 26, 1661, and headed by horseback through the harsh New England winter for the colony of New Haven. New Haven was a wise choice for many reasons. Reverend Davenport, New Haven's leading minister, had already expressed his enthusiasm for meeting with Whalley and Goffe in the letter he had written to Connecticut governor John Winthrop Jr. There is also evidence to suggest that in the days before the regicides got to New Haven, Davenport gave a series of sermons, later published as *The Saints Anchor-hold*, that he used to guide his congregation through these unsettling times. One sermon in particular, delivered on the Sabbath before the regicides' expected arrival, may have been intended to prepare his New Haven congregation for their imminent appearance. At the meetinghouse in the center of New Haven's nine-square-block layout, Davenport spoke:

> *Withhold not countenance, entertainment, and protection, from such, if they come to us from other countries, as from France or England or any other place. Be not forgetful to entertain strangers, for thereby some have entertained angels unawares. Remember them that are in bonds, as bound with them, and them who suffer adversity as being yourselves also in the body. (Heb. Xiii, 2,3)...While we are attending to our duty in owning*

Reverend James Davenport. *Courtesy of Yale Art Gallery.*

and harboring Christ's witnesses, God will be providing for their and our safety, by destroying those that would destroy his people.[134]

Sentiment in New Haven was also more outwardly hostile toward the new king than anywhere else in New England. New Haven was the only colony to consider open repudiation of the king when news of his restoration to the throne came on July 27, 1660.[135] Upon learning of Charles II's restoration, many New Haven residents no longer wished to live within the British realm. Governor William Leete wrote to Governor Peter Stuyvesant of New Netherlands, what is today New York, seeking permission for New Haven residents to move and live within his territory. Many eventually did make the move south and founded the city of Newark (today in New Jersey).[136] Unlike Massachusetts, New Haven held no realistic hope of acquiring a favorable charter, or even any charter at all, from Charles II. Therefore, New Haven magistrates, unlike those in Massachusetts, Rhode Island and Connecticut colonies, had little incentive to cooperate with royal authorities, which freed them to act as they pleased concerning the escaped judges. New Haven magistrates had nothing to gain by arresting or shunning the regicides.

The trip to New Haven from Cambridge in February was a frigid, 160-mile journey that took Whalley and Goffe west through Springfield, Massachusetts, then south through Hartford, Connecticut, and finally to New Haven on the coast. Little is documented about their trip other than that they were briefly hosted by Connecticut governor John Winthrop Jr. in Hartford and provided with a guide, Simon Lobdell, to take them to New Haven, where they arrived on March 7, 1661.[137] While making their trip south, news arrived in Boston, via a ship from Barbados, of the royal proclamation, issued in England on September 22, 1660, for the apprehension of Whalley and Goffe:

For as much as Edward Whalley, commonly known by the name of Colonel Whalley, and William Goffe, commonly called Colonel Goffe, are, amongst others, by an act of this present Parliament, entitled, an Act of Free and General Pardon, Indemnity and Oblivion, wholly excepted from pardon, and left to be proceeded against as traitors, For their execrable creations in sentencing to death, signing the instrument for the horrid murder, or being instrumental in taking away the precious life of our late dear father of blessed memory…We do hereby require and command…our judges, justices of the peace, mayors, sheriffs, bailiffs, constables and headboroughs, as also the officers and ministers of our posts, and other our subjects whatsoever… to be diligent in inquiring, searching for, seizing and apprehending them…

We do hereby declare and publish, that if any person or persons after this our proclamation published shall directly or indirectly conceal, harbor, keep, retain, or maintain, the said Edward Whalley and William Goffe, or either of them, or shall contrive or connive at any means whereby they or either of them shall or may escape from being taken or arrested…we will (as there is just cause) proceed against them that shall so neglect this our commandment with all severity.

And lastly we do hereby declare, that whosoever shall discover the said Edward Whalley or William Goffe…and shall cause them, or either of them, to be apprehended, and brought in alive or dead, if they or either of them, attempting Resistance, happen to be slain, shall have a reward of one hundred pounds in money for each of them brought in…in recompense of such his service.

This was not welcome news for Whalley and Goffe or many others in New England.[138] To this point, their hosting of Whalley and Goffe may not have made the best impression with Charles II, but

their actions had not been criminal. Now New Englanders aiding these men jeopardized their own lives and the future of their colonies.

The noose was tightening around the hunted men. While they were traveling south, a letter from the Crown commanding the arrest and reward for Whalley and Goffe arrived in Boston. Edward Nicholas, Charles II's secretary of state, wrote:

> *To our Trusty and well-beloved, the present Governor or other magistrate or magistrates of our plantation of New England.*
>
> *Charles R.*
> *Trusty and well-beloved, we greet you well. We being given to understand that Colonel Whalley and Colonel Goffe, who stand here convicted for the execrable murder of our royal father of glorious memory, are lately arrived in New England, where they hope to shroud themselves securely from our laws; our will and pleasure is, and we do hereby expressly require and command you forthwith, upon the receipt of these our letters, to cause both the said persons to be apprehended, and with the first opportunity sent over hither under a strict care, to receive according to their demerits. We are confident of your readiness and diligence to perform your duty; and so bid you farewell.*
> *Given at our Court at Whitehall, the 5th of March, 1660–1.*
> *By his Majesty's command,*
> *Edw. Nicholas*[139]

The arrival of the proclamation marked a change in the circumstances under which Whalley and Goffe could live in New England. No longer could they take part in the relatively free and public life they had enjoyed for the past eight months in and around Boston. Before the proclamation, New Englanders were threatened with the charge of treason if they assisted in harboring them. But the issuance of the proclamation now provided significant incentive for people to actively seek out the men. That meant the men must keep a low profile wherever they lived, as long as they maintained their existing identities. Although in New Haven they could enjoy the wholehearted support of the magistrates—which was no longer the case in other New England colonies—the proclamation empowered other individuals who might be seeking personal gain or revenge against the authorities to act against the men.

Nicholas's letter was directed to the governor of the "Colony of New England." Technically, there was no such colony. In a time when the colonies were circumspect about losing their autonomy, following a directive issued to the "Colony of New England" might set a dangerous precedent. Nevertheless, on March 8, 1660, Endecott and his assistants decided that the time was right to go ahead and issue a warrant for the arrest of Whalley and Goffe. Endecott made a show of thoroughly searching the town to find the men he knew had fled more than a week before. He even went one step further and appointed two young Royalists from the colony—Thomas Kirke, a merchant, and Thomas Kellond, a ship captain—to pursue the fugitives. He provided copies of the king's letter to bring with them to the other colonies and outfitted the men with horses. In the ten days that passed between the arrival of the king's letter and the departure of Kirke and Kellond, news of their mission spread quickly, and Whalley and Goffe made preparations for their arrival.[140] Endecott was sure to file a report, including a copy of his search warrant, of the vigorous steps he was taking to capture the enemies of the king.[141]

Once in New Haven, Whalley and Goffe stayed in the guesthouse of Reverend John Davenport. Shortly after their arrival, they made an excursion to Milford, a town just southwest of New Haven, where they walked about in broad daylight to let their identity be known. They hoped their actions would suggest that they were headed out of English territory on their way to New Netherlands, where the king's proclamation would not apply because it was a colony of another country. They could also have easily traveled all the way to New Amsterdam and taken a boat to essentially anywhere from that busy trading port, which would further throw off anyone following their path. Instead of heading toward New Amsterdam, however, Whalley and Goffe slipped back to New Haven and the safety of John Davenport's house.[142]

The Massachusetts arrest warrant reached New Haven on April 28, prompting Whalley and Goffe to move to a more discreet location. For the next fourteen days, they stayed with William Jones, the son of regicide John Jones, a man who shared the *Prudent Mary* with Whalley and Goffe on their way across the Atlantic.

Meanwhile, after a slow start, Kirke and Kellond eagerly departed Boston on May 7 and quickly made up ground. They followed the same path, literally and figuratively, to New Haven as Whalley and Goffe had about two months earlier but completed it in less than half the time. On May 10, they, too, were graciously hosted by Connecticut governor John Winthrop Jr., who was more than willing to issue a warrant and immediately conduct

a vigorous search of Hartford for the men he knew had left for New Haven earlier in the year. Kirke and Kellond reported, "The honorable Governor carried himself very nobly to us, and was very diligent to supply us with all manner of conveniences for the prosecution of them, and promised that all diligent search should be made after them in that jurisdiction."[143] In Winthrop's letter to Endecott dated May 11, he explained that a search was made in all parts of the colony as he promised but that the men could not be found. Winthrop arranged for Samuel Martyn of Wethersfield to guide the two agents to the colonies of New Haven and New Netherlands on May 12.

As historian Lemuel A. Welles points out, someone must have left Hartford before Kirke and Kellond to alert Whalley and Goffe of their activities, because on the very day they arrived in New Haven, Whalley and Goffe left Jones's house to hide in a mill on the edge of town about two miles away.[144] Kirke and Kellond arrived that evening in the town of Guilford, east of New Haven, where they went to Deputy Governor Leete's house to present their papers to him. Leete began to read the letters out loud, thereby informing the others in the room of their contents, until he was interrupted by the agents: "Would his Honor please not read so loud? It is convenient to be more private in such concernments as this is." The men retreated to a more private room, where Leete explained that he had not seen the men in nine weeks. Kirke and Kellond said they had heard from others that Whalley and Goffe had been there more recently. They requested fresh horses for their trip back to New Haven that night. Leete refused to provide the horses at the beginning of the Sabbath, and though they chafed at Leete's obstructionism, the frustrated agents made their way to the local tavern.[145] On their way, they were approached by a local man named Dennis Crampton. Crampton was no friend of Leete; he had recently been whipped for a misdemeanor by the order of the governor and undoubtedly relished the opportunity to make trouble for him. Crampton reported the truth to the men. His information was nearly completely accurate and reveals just how well informed about all of this the common resident could be. Crampton correctly suspected that Whalley and Goffe were living with Reverend Davenport. He knew Davenport had "put in ten pounds' worth of fresh provisions at one time into his house, and that it was imagined it was purposely for the entertainment of them."[146] He also knew that Whalley and/or Goffe left Davenport's to stay at the house of William Jones across the street. Crampton was prepared to testify under oath that, while training with a company of militia, Whalley and Goffe were heard to say that if they had two hundred friends who would

stand by them, they would not care for England, new or old. By this point in the conversation, several others had gathered around, confirming and adding to Crampton's account.[147]

Armed with this new information, Kirke and Kellond returned to Leete and pressed him a second time for fresh horses, a guide and a warrant for the arrest of Whalley and Goffe. But by this time it was near nightfall, which marked the beginning of the Sabbath, which was strictly and legally enforced in the Puritan colony. Leete willingly provided the horses but said he could not provide the warrant without first consulting Mathew Gilbert and the rest of the New Haven magistrates. But with the next day being Sunday, the business would have to wait. Eager to act but stymied by Leete, Kirke and Kellond departed. As they headed toward the local inn, Crampton again intercepted them and let them know that a local Indian was missing from town and that Crampton suspected he was going to New Haven to warn the regicides of the agents' presence. They also learned that a man named John Meigs was preparing to leave Guilford that night for New Haven by horse. They again returned to Leete in an attempt to pressure him to summon Meigs and inquire about his business. Leete refused, saying he did not know anything about it.[148]

Early Monday morning, May 13, Kirke, Kellond, their guide and Leete all made their way from Guilford to New Haven. Whalley and Goffe were aware of their impending arrival and fled to a cave in the wilderness. They were guided there by two local farmers, Richard Sperry and another man whose last name was Burrill. Sperry owned land outside town in a valley below the peak that Whalley and Goffe referred to as Providence Hill but that today is known as West Rock. A pile of huge boulders on the hillside formed a cave that could be made into an isolated shelter. Whalley and Goffe may have camped at a spring called Hatchet Harbor, or possibly "the Harbor," also located on Sperry's land, for two days until the rocks could be made into a suitable shelter.

Governor Leete, who departed after the agents from Guilford, stopped along the way in Branford to bring Jasper Crane, another local magistrate, to New Haven with him. He also sent for the remaining magistrates to return to New Haven from their respective towns to help determine how to proceed. Two hours after Kirke and Kellond arrived, Leete, traveling at a leisurely pace, was finally ready to meet with them. As in Guilford two days earlier, Leete showed little cooperation and stalled for time at every opportunity. Asked again for assistance to search and arrest Whalley and Goffe, Leete again resisted. He explained that he did not think Whalley

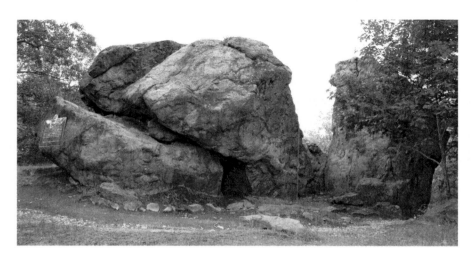

Judges Cave. *Photography by Nicole Marino, private collection.*

and Goffe were in New Haven. The agents asked Leete to empower them or another man with a warrant to search the town, specifically the houses of Davenport and Jones, and make an arrest. Leete replied that he could not and would not make another man a magistrate of the town without first meeting with the freemen. Exasperated, Kirke and Kellond reminded Leete that the honor and service of his majesty was being "despised and trampled upon by him" and that they suspected that by his "unwillingness to assist in the apprehension, he was willing they should escape."[149] Leete left the men to consult with other town leaders. Their meeting lasted five or six hours. When he finally returned, he still refused to provide the men with their warrant. Kirke and Kellond presented Leete with the warrants provided by Governors Endecott and Winthrop and reminded him how "ill his sacred majesty would resent such horrid and detestable concealments and abettings of such traitors and regicides as they were, and asked him whether he would honor and obey the King or not in this affair, and set before him the danger which by law us incurred by any one that conceals or abets traitors." Leete answered that he honored his majesty but that he was wary of the implications of obeying a letter written to a governor of New England, a general governor.[150] Kirke and Kellond accused Leete of using that as an excuse, for the governors of Connecticut and Massachusetts did not have a problem issuing the order. This sent Leete back to the other magistrates for an additional two hours.

Finally, at nightfall, Leete reappeared. Weary of the day's contention, Leete took one of the men by the hand and explained how he "wished he had been a ploughman and had never been in the office, since he found it so weighty." Kirke and Kellond again reminded Leete of the ruin he could bring on himself and the colony of New Haven by failing to comply with the king's command. They asked Leete if he would "own," or recognize the authority of the king, or not, to which Leete replied, in a reference to New Haven's uncertain status as a colony, that he would prefer to know whether the king would "own," or recognize their legitimacy as a colony, then.[151] Kirke and Kellond left and searched the town to the extent they could without a warrant. Of course, they found nothing, Whalley and Goffe currently being in the wilderness and living in the cave. Before moving on to New Netherlands, the agents offered a hefty financial reward for anyone who helped them find the fugitives should they return.[152]

Three days after Kirke and Kellond's departure, the New Haven General Court met to determine what should be done about Whalley and Goffe within its colony. Leete insisted they were not in town. The New Haven General Court had a different version of events from the claims made by Kirke and Kellond. According to the records of the General Court, Leete explained that after meeting initially with Kirke and Kellond in Guilford, he provided Kirke and Kellond with a letter to Matthew Gilbert, the New Haven magistrate, to search the town immediately. However, when Kirke and Kellond arrived in New Haven, Gilbert was nowhere to be found to execute the order. Later, when Leete arrived in New Haven, he sent for Gilbert, as well as Robert Treat (of Milford) and other deputies of the New Haven court. While he waited, Leete stated that after resisting for some time, probably referring to his five-hour meeting, he did in fact submit to the pressure of Kirke and Kellond and began writing out a search warrant, only to be interrupted by the arrival of Treat and Gilbert. It was these men who then persuaded Leete to wait to issue the warrant until the General Court could be convened. Now, with the General Court in session, the court officially declared that no one knew the wanted men were hidden in town and proceeded to take care to "send forth the warrant that a speedy diligent search be made throughout the jurisdiction, in pursuance of his Majesty's commands." The court also dismissed the rumors of Whalley and Goffe's concealment in New Haven as being "unjust suspicions, and groundless reports against the place, to raise ill surmises and reproaches."[153]

Kirke and Kellond took their investigation to New Netherlands, where they met with Peter Stuyvesant, the director general of New Netherlands. Stuyvesant cooperated with the agents, even ordering a search of all private vessels in the harbor. However, Stuyvesant, being accountable to authorities in the Netherlands, not England, would not guarantee the arrest of the fugitives. Whalley and Goffe, of course, were not in that colony, and after their fruitless search, Kirke, Kellond and Martyn returned to Boston by sea, where they filed a report and swore an oath to the accuracy of their information.[154] As a reward for their vigorous efforts, Kirk and Kellond were each granted 250 acres of land.

While the New Haven court quibbled, and Kirke and Kellond searched Manhattan, Whalley and Goffe set up camp in their newest home, the cave on West Rock just outside of town. For nearly a month, from May 15 to June 11, 1661, they subsisted on provisions provided by Richard Sperry and delivered by his sons. One family legend, passed on through three generations of Sperrys, says that one evening while Whalley and Goffe were asleep, a mountain lion came wandering about the cave. The men awoke to the sight of two large, glowing eyes starring in at them. The sight sent at least one of the men tearing down the mountain toward the safety of the Sperry farm.[155]

Tensions were running high in New Haven. There was little to gain by helping these men escape the law, and there could not be more to lose. Individually and publicly, the stakes could not be higher. The concealment of Whalley and Goffe in their homes, the obstruction of Kirke and Kellond's search by colony magistrates and the keeping of inaccurate records made by the General Court all reeked of treason. Undoubtedly, more citizens were involved in these events than are known today. If found to be aiding these men, their lives were on the line, and the governance of New Haven would likely be placed under royal authority. Regicide historian Lemuel Welles reports some mysterious events that took place in the weeks and months following the search. One man named Rossiter, from Guilford, was reportedly imprisoned for putting in writing a complaint of Leete's actions concerning the events. New Haven also had irregular difficulty in getting men to serve in their elected positions. Welles documents at least five cases where men refused service during this time. Perhaps these men preferred to remain as farmers, as Leete had wished for himself, rather than deal with the mess.[156]

In the wake of the controversy, Whalley and Goffe, aware of the sacrifices being made on their behalf, decided on June 11 to turn themselves in. Before showing up in New Haven, it is reported that they first went to another

colony (Connecticut and New Netherlands were both close by), perhaps to give the impression that they had been out of New Haven for some time. They appeared openly in New Haven on Saturday, June 22, eleven days later. This ruse cleared the names of Davenport, Jones and any others suspected of hiding the men in their homes. They let Deputy Governor Leete know they were there and, before their arrest, requested "a little time to be private by themselves." Whalley and Goffe then attended church that Sunday, only to make their escape the following day, where they were spotted by a local boy in a cornfield retreating back to their cave on West Rock. Predictably, Leete immediately ordered a thorough search of the town long after the men were known to have escaped.

Massachusetts authorities, keenly aware of the public relations beating New England was taking in London, felt obliged to inform and warn New Haven of the danger of its actions. Even before this most recent incident, Massachusetts secretary Rawson had been in the midst of writing to Governor Leete. "I am required to signify to you as from them, that the non-attendance with diligence to execute the kings majesty's warrant for the apprehending of the Colonels Whalley and Goffe will much hazard the present state of these colonies and your own particularly, if not some of your persons, which is not a little afflictive to them," he wrote.[157] This letter was initially dated July 4, 1661.

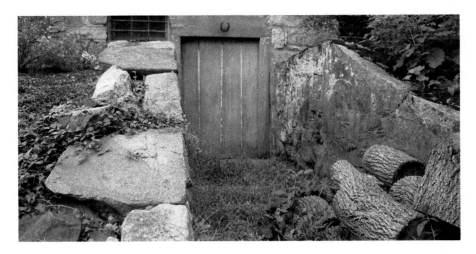

Oral tradition states that Edward Whalley and William Goffe hid in this cellar behind the home of Governor William Leete for several days while planning their ruse to turn themselves in to New Haven officials. This legend has been called into question by more modern scholarship. *Photography by Nicole Marino, private collection.*

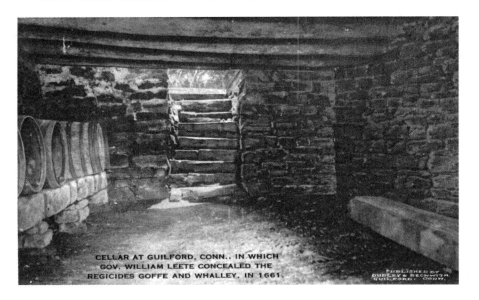

CELLAR AT GUILFORD, CONN., IN WHICH
GOV. WILLIAM LEETE CONCEALED THE
REGICIDES GOFFE AND WHALLEY, IN 1661.

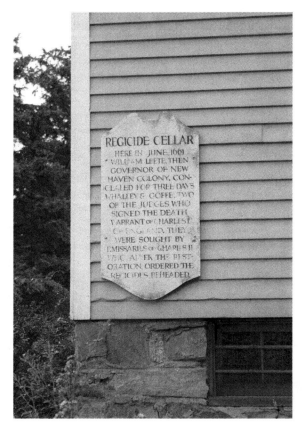

Above: An interior image of the regicide cellar. *Private collection.*

Left: Regicide cellar sign. *Photography by Nicole Marino, private collection*

However, before he finished writing, Rawson learned of Whalley and Goffe's most recent exploits. In his postscript, he adds that he knew Whalley and Goffe had given themselves up but that Mr. Gilbert, magistrate of New Haven, had failed to guard them to ensure their arrest. He followed, "Sir, how this will be taken is not difficult to imagine, to be sure not well…I am not willing to meddle with your hopes, but if it be a duty to obey such lawful warrants, as I believe it is, the neglect thereof will prove uncomfortable."[158]

Desperately in need of some damage control, Governor Leete and Reverend Davenport began to mount a defense. For his part, Governor Leete summoned the General Court for a meeting on August 1. In its reply to Secretary Rawson, it explained that it hoped to receive the king's forgiveness for its failure to arrest Whalley and Goffe. Its explanation was because of its naïveté over Whalley and Goffe, the way they "pretended reality to resign up themselves, according to their promise to save the country harmless."[159] For his part, Davenport wrote a letter to Colonel Temple, a Royalist magistrate in Massachusetts, to explain his side of the story. Davenport wrote to Temple his version of events that he hoped would be communicated to the king's court in London. His motivation was to set the record straight, for he was sensitive to the misrepresentations of his actions and intentions that were being spread in Boston and London. He wrote:

> *This is my great intendment in this lines, humbly to crave your mindfulness of me & helpfulness toward me in this exigent, and not for myself alone do I make this humble request, but also on behalf of this poor colony & our Governor & magistrates, who wanted neither will nor industry to have served his Majestie in apprehending ye 2 Colonels, but were prevented & hindered by gods overruling providence, which withheld them that they could not execute true purpose therein; And the same providence could have done ye same, in the same circumstance, if they had been in London, or in the Tower.*

To Davenport's mind, Whalley and Goffe's escape was due to divine providence rather than lack of effort on the part of New Haven. The same outcome would have happened in England, he reasoned.[160] It is not surprising that Davenport, Leete and others were the subject of intrigue. The course of events certainly point to a preconceived plan that would exculpate New Haven while still providing Whalley and Goffe refuge. In retrospect, our full awareness of the cozy relationship shared between the fugitives and many of the town's leaders and residents makes those people's guilt seem even more apparent.

Early Searches for the Regicides

Date	Location	Details
March 8, 1661	Boston, MA	Search made by warrant, issued by Governor Endecott after Whalley and Goffe were informed of events by their host and Colony Assistant Daniel Gookin. Whalley and Goffe had already departed for New Haven.
March 11, 1661	Hartford, CT	Search made by a warrant issued by Governor Winthrop after the regicides were no longer in the colony. Whalley and Goffe had left days earlier on their way to New Haven.
March 13, 1661	New Haven, CT	Search made by agents Kirke and Kellond after Whalley, Goffe and local magistrates were informed of their impending arrival by John Meigs or a local Indian. Whalley and Goffe were hidden first in a mill outside of town and then at Judges Cave.
March 17, 1661	New Haven, CT	Search made by warrant issued by Governor Leete following days of deliberation and obstruction.
June 24, 1661	New Haven, CT	Search made by warrant issued by Governor Leete after Whalley and Goffe appeared openly to turn themselves in, only to escape again.

CHAPTER 12

MILFORD

In August 1661, Whalley and Goffe were living at the home of Michael Tompkins in the center of Milford. Goffe wrote in his diary that he and Whalley had dared "not so much as walking out into the orchard for two years." The house was about twenty feet square and had two stories. Whalley and Goffe lived in the stone storeroom, which may have been a basement. The family used the upper room as a workroom, and the daughters and other girls would sometimes spin yarn in the building. During this time, legend has it, a "ludicrous cavalier ballad, satirizing Charles's judges, Whalley and Goffe among the rest," was brought over from England and was frequently sung by the girls while two of the actual judges were secretly hidden below. Nevertheless, Whalley and Goffe were "humored and please with it," even though they were the "subjects of the ridicule."[161] In time, as the men settled into their home in Milford, they began to meet with local visitors, including Davenport on numerous occasions, with whom they prayed and preached.[162]

Around this time, Whalley and Goffe exchanged many letters with family members and acquaintances from England, both old and new, for the first time. Judging by the people who wrote, received and delivered the letters, it is clear that Whalley and Goffe had a network of influential New Englanders working on their behalf. It is also clear that by this time, and possibly much earlier, some of their family members and friends in England knew of their whereabouts. Most of the letters were passed through, and later preserved in the library of, the prominent Boston minister Reverend Increase Mather, who sent and received many of the letters.[163] Whalley and

Goffe were kept abreast of the plight of the Puritans in England as well as of bills in Parliament and a speech by the king to Parliament. As men who formerly held significant power, their new isolated life in the far reaches of civilization made them thirst for information about everything from the local church to world affairs.[164] Goffe was also able to communicate with his wife (who was Whalley's daughter), Frances. Her letter strongly suggests that this was among their first contact since Whalley and Goffe's voyage almost exactly two years earlier:

My dearest Heart,

I have been exceedingly refreshed with your choice and precious letter of the 29th May, 1662…The preservation of yourself and my dear father, next to the light of his own countenance is the choicest mercy that I enjoy. For, to hear of your welfare gives, as it were, a new life to me. Ah! What am I, poor worm, that the great God of heaven and earth should continue such mercies to me and mine, as I at this day enjoy…I shall now give you an account of your family, as far as I dare. Through mercy, I and your little ones are in reasonable health, only Betty and Nan are weakly, and I fear will be lame a little, the others are very lusty…I do heartily wish myself with thee, but that I fear it may be a means to discover thee…and therefore I shall forbear attempting any such thing for the present, hoping that the Lord will, in his own time, return thee to us again;…My dear, I know you are confident of my affection, yet give me leave to tell thee, thou art as dear to me as a husband can be to a wife, and, if I knew anything that I could do to make you happy, I should do it, if the Lord would permit, though to the loss of my life…I know not whether I may ever have another opportunity to send to you this season or not, which makes me the longer now; for I shall not send but by those I judge to be faithful; and, I being in the country, I may not hear of every opportunity; and, though it is an unspeakable comfort to me to hear of thy welfare, yet I earnestly beg of thee not to send too often, for fear of the worst; for they are very vigilant here to find out persons. But this is my comfort, it is not in the power of men to act their own will. And now, my dear, with 1000 tears, I take my leave of thee, and recommend thee to the great keeper of Israel, who neither slumbers nor sleeps, who, I hope, will keep thee, and my dear friend with thee, from all your enemies, both spiritual and temporal, and in his own time return you with safety to your family. Which is the daily prayer of thy affectionate and obedient wife, till death, F.[165]

Frances was right to be weary. The letters the men received also brought foreboding news from abroad. One of Whalley and Goffe's fellow judges, John Downes, had his sentence commuted from death to life imprisonment. The news reached Whalley and Goffe on December 18, 1661, and was likely passed along by Wait Winthrop, the son of Connecticut governor John Winthrop Jr. Wait had initially been informed by a man named John Pynchon, of Springfield, Massachusetts, who had actually formed a secret group consisting only of three men (Pynchon, Captain Richard Lord of Hartford and the aforementioned Colonel Thomas Temple of Boston) dedicated to capturing fugitives.[166] While the news about Downes was optimistic, the fate of three others was not. Like Whalley and Goffe, fellow judges John Barkstead, Colonel John Okey and Miles Corbet fled abroad at the Restoration. These three men were captured while in Holland through the deceit of their "friend" George Downing. Downing, a New Englander, had first earned the men's trust and then duped them into a carefully laid trap. All three men were arrested and brought back to England, where they were hanged, drawn and quartered in April 1662.[167] While talk of Davenport and Leete in the king's court had died down, any similar hope that Whalley and Goffe had been forgotten in obscurity was lost. Some rumors in the royal government placed them in Belgium. Another had them assassinated in Switzerland (a tale that Whalley and Goffe read with amusement). But Thomas Temple had correctly informed the court he suspected Whalley and Goffe to be in southern New England.[168]

Just across the street from the house in which Whalley and Goffe were hidden lived a man named Benjamin Fenn. Fenn, along with Governor Leete, was a representative of New Haven colony to the United Colonies of New England, a confederation of four New England colonies (Connecticut, Plymouth, Massachusetts and New Haven) created to provide for their common military defense and resolve inter-colony disputes. During their meeting in September 1661, just as Whalley and Goffe had moved into Tompkins's house, the subject of the king's warrant came to a head. The confederation resolved to draft a declaration, dated September 5, which included the following wording:

> *And whereas not withstanding it is probable that ye said concerned persons may remain still hid in some parts of New England...These are therefore seriously to admonish & advise all persons thatsoever within the said Colonies not to rescue, harbor, conceal or sucker the said persons so attainted...And*

we do hereby declare that all such person or persons that since ye publication of his Majesties order have wittingly or willingly entertained harbored or concealed the aforesaid Whalley and Goffe or hereafter shall do ye like have and will incur his Majesties highest displeasure and is intimated in ye said order and will be accounted enemies to ye public peace of the united colonies and may expect to be and proceeded with accordingly.

The margin of the Connecticut copy of the record of the meeting includes a note that states, "Benjamin Fenn consenteth not to this declaration."[169] Leete, fearing for his own well-being, signed the document, but Fenn held out. Like Davenport before him, Leete now felt compelled to apologize for his conduct concerning the regicides. John Norton, a minister of the Commonwealth faction in Massachusetts, wrote to Richard Baxter on Leete's behalf. Baxter was serving for a time as a royal chaplain and may have had some influence in the court. Baxter perhaps was sympathetic to Leete, as Edward Whalley had been a common friend. During the English civil war, Baxter served as a chaplain in Whalley's Ironsides Regiment. Baxter thought so highly of Whalley at the time that he dedicated one of his works, *The Apology*, to the colonel. In hindsight, the dedication contains a bit of irony: "Think not that your greatest trials are now over. Prosperity hath its peculiar temptations by which it hath foiled many that stood unshaken in the storms of adversity. The tempter who hath had you on the waves, will now assault you in the calm, and hath his last game to play on the mountain, till nature cause you to descend. Stand this charge, and you will win the day."[170]

Norton may have chosen to write Baxter in hopes that he would be sympathetic to someone who had helped his former friend. In his letter to Baxter, Norton writes that Leete, "being conscious of indiscretion and some neglect (not to say how it came about)…according to his Duty, sent from his Majesty for the apprehending of the two Colonels, is not without fear of some displeasure that may follow thereupon, and indeed hath almost ever since been a man depressed in his spirit for the neglect wherewith he chargeth himself therein."

Norton states that Leete and his neighbors attest that he could not have done more to arrest the judges. Norton assured Baxter that if anyone suggested otherwise, he could report his testimony as "a real truth."[171]

It appears Leete was stirring up trouble for himself unnecessarily. A man named Robert Newman later wrote to Matthew Gilbert on February 12, 1662: "I am sorry to see that you should be so much surprised with fears of

what men can or may do unto you. The fear of an evil is often times more than the evil feared. I hear of no danger, nor do I think any will attend you for that matter. Had not W.L. [William Leete] wrote such a pitiful letter over, the business I think would have died."[172]

Shortly after these correspondences came the devastating news that Charles II had placed the New Haven colony under the authority of Connecticut in a new charter. Not a single New Haven man was among the patentees. The colony lost its self-rule and was now under the jurisdiction of its neighbor to the north and east. Unlike the other New England colonies, New Haven had been established without any legal legitimacy, and its people reacted with hostility upon learning of the return of English monarchy. New Haven's feeble and dubious efforts at arresting Whalley and Goffe certainly had not won the colony any friends in London. Other New England colonies were well aware of New Haven's vulnerability and lusted after the colony's land. It was Connecticut's representative, the charismatic and well-connected John Winthrop Jr., who won the day for Connecticut colony. His negotiations for a new charter resulted in a land grab that greatly increased the size of Connecticut at the expense of its colonial neighbors. In one swipe, the Connecticut charter incorporated all of New Haven, all of Long Island and parts of Rhode Island to the Connecticut colony. For many in New Haven, this was an outrage. Some residents refused to submit and moved to Newark, New Jersey, entirely out of the English realm. Those who stayed simply refused to submit to Connecticut authority and appealed to the king for a change. Likewise, the Dutch rejected the charter's presumed authority over territory also claimed as part of New Netherlands, and tension turned to violence on the new Connecticut and Rhode Island border. The royal court was filled with claims and counterclaims made by the opposing sides.

On June 28, 1662, as part of his effort to put his differences with the colonies behind them, Charles II wrote a letter to Massachusetts pardoning anyone who committed crimes and offenses against him. This pardon included any offense except "any such persons who stand attainted by our parliament here of high treason, if any such persons have transported themselves into those parts; the apprehending of whom and delivering them into the hands of justice we expect from dutiful and affectionate obedience of those of our good subjects in that colony, if they be found within the jurisdiction and limits thereof."[173]

In the wake of the complaints and disarray among the colonies, Charles created a four-man commission of inquiry to come to New England in 1664.

The representatives were Colonel Richard Nicolls, Sir Robert Carr, Colonel George Cartwright and Samuel Maverick.[174] Samuel Maverick was already in favor of consolidating all of New England into a single colony under royal control. Nicolls's mission was to seize New Netherlands and head a commission of inquiry to hear and decide all territorial and intra-colonial disputes in New England. A third part of their mission was to find and arrest the regicides, along with those who had helped hide them.

You shall make due enquiry, who stand attainted here in Parliament of high treason, have transported themselves thither, & do now inhabit or reside or are sheltered there, and if any such persons are there, you shall cause them to be apprehended and to be put on shipboard and sent hither; to the end that they may be proceeded with according to law. And you shall likewise examine whether any such persons have been entertained & received there since our return into England, & what is become of them, & and by whom they were received and entertained there; to ye end & for not other (for we will not suffer ye Act of Indemnity to be in any degree violated) that those persons may be taken ye more notice of, & may hold themselves to take ye more care for their future behavior.

To accomplish these objectives, the commission was armed with the full authority to act on behalf of the king. The assistance of four hundred soldiers aboard four frigates might help.

CHAPTER 13

THE ANGEL OF HADLEY

The squabbling between the colonies, and their poor adherence to the king's requests, now endangered the colonies' very existence. Suddenly New Haven, which had earlier been surprised and outraged at the Connecticut charter, decided to submit to Connecticut jurisdiction without a fight. When the warships arrived in New England, two at Portsmouth on July 20, 1664, and two others at Boston on June 23, Massachusetts thought the barrels of guns aboard the frigates would be pointed at them instead of, or in addition to, New Netherlands.[175] Massachusetts's initial response was to summon the militia, hide its charter and strengthen the forts around Boston. When the warships arrived, the captains of the militia rowed out to greet and inform them that if the soldiers intended to get off the ships, they would have to do so without their weapons.[176]

Colonial officials were not the only ones scared by the presence of Crown warships. When Whalley and Goffe learned of the arrival of the commissioners in 1664, they immediately abandoned Tomkins's house in Milford for the isolated safety of the cave on Providence Hill for the third and final time. This stay was the shortest of the three. After little more than a week in the wilderness, they were discovered by some local Indians hunting in the area, which jeopardized their safety. On October 13, 1664, Whalley and Goffe left New Haven for the isolated frontier town of Hadley, Massachusetts. It was likely Davenport, through his friend William Goodwin, who arranged for Whalley and Goffe to stay at the house of Reverend John Russell in Hadley.

Meanwhile, Charles II's commission was busy at work in New England. Shortly after their arrival on the shores of New England, the four frigates sailed south to New Amsterdam and successfully seized the territory without a fight. The city was renamed New York in honor of Charles II's openly Catholic brother James II, the Duke of York, to whom all territorial gains were granted. This was a nightmare scenario for much of New England. Along with the former territory of New Netherlands, Charles added all of Long Island, as well as Block Island, Martha's Vineyard, Nantucket, parts of modern-day Maine (then Massachusetts) and half of modern-day Connecticut; all were placed under the authority of the Duke of York. Not only did New England suffer damaging territorial losses, but the move also suggested that Charles II was moving toward a consolidation of the New England colonies under a single government. The commission of inquiry heard disputes and complaints and tried to compel Massachusetts to comply more fully with royal orders, to no avail. Concerning Whalley and Goffe, the commission correctly suspected Captain Daniel Gookin of assisting the men, but it wrongly accused him of maintaining their estates. More specifically, Gookin was accused of raising Whalley's or Goffe's cattle on land in modern-day Rhode Island. The Massachusetts courts, however, boldly refused to recognize the authority of the commission, and they were forced to drop the charges.[177] The commission returned to London with a recommendation that the Massachusetts charter be revoked to enforce full submission to the king's requests. As a result of their report, Gookin and other obstinate colonial leaders were ordered to go to England and answer the charges, but Massachusetts refused to send the men over. Shortly thereafter, a war with the Dutch broke out, largely because of the seizure of New York. That distracted the court from its issues in New England, and Lord Clarendon, chief advisor to the king and an enemy of New England, fell from power.[178]

Located about 80 miles north of New Haven and 105 miles west of Boston, Hadley was as remote a town as any in New England at the time. Hadley had been settled only five years earlier by a small group of dissenting congregants from Wethersfield, Connecticut. The farming community was centered on a mile-long rectangular green traversing a stretch of farmland and surrounded on three sides by a sharp bend in the Connecticut River. Reverend John Russell's house, where Whalley and Goffe lived for the next decade, stood near the center of the green. The house was built in the standard design of its day, standing about forty feet wide and twenty feet deep, with two large rooms on each side of a large chimney in the center.

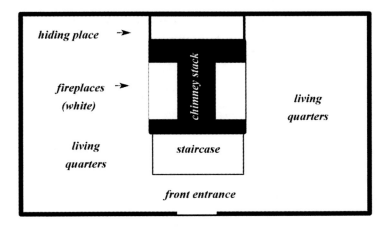

Russell House Floor Plan
(Approximation)

Above: The floor plan of Reverend John Russell's house reveals the location of the secret space behind the chimney in which Edward Whalley and William Goffe hid themselves during emergencies. *Courtesy of Linda Pagliuco.*

Right: This picture, taken from a house with a nearly identical floor plan and dimensions to Reverend Russell's house, reveals a likeness to the small space on the first floor where Whalley and Goffe hid. In this house, the space is used as a narrow hallway in the rear of the house. In Reverend Russell's, both sides of the space were sealed off by walls, making the space accessible only through the floorboards of the second story. *Private collection.*

The layout of the second floor was identical to the first. With the chimney in the center, there was a small amount of usable space left in the front and rear of the house. In the front, the space was typically used as a hallway between rooms and a stairwell to the second floor (or, on the top story, a stairway to the attic). There was even less space behind the chimney. In the Russell house, this narrow space was closed off on the ground floor, and on the second story, where Whalley and Goffe lived, was a hallway between rooms. The floorboards in that space could be removed to reveal a hidden space behind the first-floor chimney that the men could slide into in case of emergency. This design was a deviation from the normal use of that rear space, which would typically have been accessible from the ground floor.

A look at a map of the small frontier town, which would soon be surrounded by a protective stockade, makes it difficult to imagine that the residents of the town did not know of Whalley and Goffe's presence in Russell's house. Certainly some must have noticed men looking out the upstairs windows or the sound of deep voices echoing out of the open windows during the hot summer months. As a local and regional leader, Russell undoubtedly hosted visitors of all types on a regular basis, which made the prospect of Whalley and Goffe's discovery even more likely. In an account recorded more than fifty years later, an eighty-six-year-old woman named Lydia Fisher, of Dedham, Massachusetts, remembered working as a

VILLAGE OF HADLEY IN 1663.

THE MEADOW PLAIN.	RIVER				STREET.	Nichols	John Ingram 2	John Taylor 2	Wm. Pixley 2		PINE PLAIN, OR WOODS.
	Samuel Gardner,	4									
	North highway to the meadow.										
	Chileab Smith,	8				William Partrigg,		8			
	Joseph Baldwin,	8				Thomas Coleman,		8			
	Robert Boltwood,	8				Samuel Smith,		8			
	Francis Barnard,	8				Philip Smith,		8			
	John Hawks,	8				Richard Montague,		8			
	Richard Church,	8	M.			John Dickinson,		8			
	Edward Church,	8				Samuel Porter,		8			
	Middle highway to the meadow.					Thomas Wells,		8			
	Henry Clark,	8				John Hubbard,		8			
	Stephen Terry,	8				Town Lot,		8			
	Andrew Warner,	8				Mr. John Russell, Jr.		8			
	John Marsh,	5½				Middle highway to the woods.					
	Timothy Nash,	5½				John Barnard,		8			
	John Webster,	5½				Andrew Bacon,		7			
	William Goodwin,	8				Nathaniel Stanley,		5			
	John Crow,	8				Thomas Stanley,		5			
	Samuel Moody,	7½				John White,		8			
	Nathaniel Wood,	8½				Peter Tilton,		8			
	William Markham,	8				William Lewis,		8			
	South highway to the meadow.					Richard Goodman,		8			
	Joseph Kellogg.					William Westwood,		8			
	AQUA VITAE MEADOW.					Thomas Dickinson,		8			
	RIVER.					Nathaniel Dickinson,		8			
						South highway to the woods.					
						John Russell, sr.		8			

A map depicting the original settlement of Hadley, Massachusetts. Reverend John Russell's house is located in the center-right portion of the map. *Courtesy of Homer Babbidge Library, University of Connecticut.*

servant for the two men in Russell's house for about a year.[179] But Hadley provided Whalley and Goffe the safe cover and low profile they needed to avoid detection better than Boston or New Haven ever could.

Goffe wrote to his wife, who was still living in England, that the country life of Hadley agreed with him, although he found New England's winter cold to be biting.[180] His wife recommended that he wear a wig, which was the new fashion in London, so that he might "enjoy more of the air." She offered to send him one. He responded, "I humbly thank you for the continuance of your motherly affection towards me, most unworthy thereof, and in particular for your care to fence me against the cold air. But the way you propose will not do it, for I must tell you the air of this country in the winter is exceeding piercing, that a sickly person must not dare to venture out of doors."[181]

Goffe's letters also reveal that he and Whalley were running a small trading business with the local Indians. So prosperous was this venture that they became self-sufficient. Goffe was thus able to pay off all his debts and no longer needed financial assistance from his friends in England. Some have suspected that Whalley and Goffe paid Russell well in return for their concealment. Russell was able to send two of his sons to Harvard, an expense not normally affordable to a preacher of Russell's status.[182]

Whalley and Goffe were occasionally visited by their Hadley neighbors Peter Tilton and William Goodwin and by visitors from afar. In February 1665, John Dixwell, an old acquaintance from their years under Cromwell, visited them. Dixwell was less active in the civil wars than Whalley and Goffe had been, but he was elected to Parliament in 1646, serving for Dover. While in Dover, Dixwell became a supporter of the Independent faction, thereby aligning himself with the interests of the army. He was one of the 160 men nominated to the high court of justice, and as one of the few who attended every session of the king's trial, he likewise signed the death warrant of Charles I. So Dixwell, too, was a wanted man on the run for his life. Dixwell survived Pride's Purge of Parliament and went on to serve in all three Protectorate Parliaments (of 1654, 1656 and 1658). If not for his signature on the death warrant, Dixwell would have faced little, if any, persecution after the restoration of Charles II. However, when he learned of Charles II's impending return, he fled to Hanau, Germany. Unlike Whalley and Goffe, who were initially welcomed openly in Boston, Hartford and New Haven, Dixwell slipped seamlessly and unnoticed into New England, the Crown never learning of his whereabouts. His visit with Whalley and

Goffe was likely one of his first stops upon his arrival in New England. After an extended visit there, Dixwell made his way south to New Haven, where he lived a happy and prosperous life for more than twenty years under the alias James Davids. Predictably, John Davenport was eager to meet with Dixwell at the time. In a letter to Goodwin, he wrote, "It would exceedingly refresh me, if I could speak freely & fully with those three worthys your neighbors."[183] That letter was dated November 1665.

As time passed, the lives of Whalley's and Goffe's loved ones back in England moved forward as well. In 1674, in a letter from his ailing friend William Hooke, Goffe received major news about his family. His eldest daughter had recently converted to Puritanism, and she had married. Her husband was "a salter by trade, gentleman, and one that liveth well," according to their friend William Hooke, who, with his wife, was taking care of Frances.[184] The same letter also brought the sad news of the death of Goffe's middle daughter, Elizabeth. In August, Goffe wrote a long letter to Frances in response to all this news. It contains the only real, first-person glimpse into his personality and personal life. Of his eldest daughter's conversion, Goffe writes, "That which you write concerning Dear Frank I cannot read without tears, not of grief but of joy, for I have no greater joy than to hear that your children walk in the truth." Goffe was eager to learn more about his new son-in-law, requesting of Frances, "Speak a little more fully concerning his Godliness, for you say nothing to that, except by the phrase of a very honest man, you mean a very Godly man, as I hope you do."[185] Of the death of his other daughter, Goffe wrote his wife tenderly, "Dear Mother, I have been hitherto congratulating my new married sister, but I must now turn aside to drop a few tears upon the news of her that is deceased, whose loss I cannot choose but lament with tears & so share with you in the providences of God towards us; but my dear Mother let me not be the occasion of renewing your Grief for I doubt not but you have grieved, if not too much already."[186]

At the end of this long and emotional letter, Goffe includes a memorable postscript that provides insight into the nature of his marriage during and prior to his exile. He writes:

Now my Dear Mother, give me leave in a postscript to be a little merry with you, & yet serious too. There is one word in one of your letters that sounds so harshly & looks so untowardly that I cannot tell well how to read or look upon it, & I know not how to write it, & yet I must, though: I cross

it out again. I suppose you do by this time sufficiently wonder what will follow; but the matter is this. After you had given me a loving account of a business wherein you have done your best, you were pleased to say, the if I should be angry *you had many to bear with you &c. Rash anger, I confess, is a burden that needs more shoulders than one to bear it, for Solomon saith a stone is heavy & sand weighty but a fool his wrath is heavier than them both. But oh, my dear mother how could you fear such a thing from me? Yourself knoweth I never yet spake an angry word to you, may I hope I may say, without taking the name of God in vain, the Lord knoweth I never conceived an angry thought towards you, nor do I now, nor I hope never shall. And in so saying I do not commend myself, for you never gave me the least Cause, neither have you now, & I believe never will.*

It is unfortunate that we do not have Frances's reply.

Goffe and Whalley, too, were getting on in years. While Whalley contributed to some of the letters, none of those preserved were written specifically to or by him. In a 1671 letter, Goffe must have written to his wife about a malady her father was experiencing, about which she advised, "Surely tobacco is very good for your friend; but, by the next I hope to send some particular direction, for I purpose to take advice of an old friend; but this is so sudden that I have no time."[187] By 1674, judging by Goffe's description to his wife and William Hooke, Whalley had suffered a stroke and was in a weakened state. Goffe told his wife that Whalley is no longer capable of rational discourse and has trouble speaking, only able to answer simple questions with short answers. His memory was also fading, thereby making speech frustrating and difficult. Whalley had to use hand gestures to communicate. "His finger is often-times a better interpreter of his mind than his tongue," Goffe wrote. Goffe was grateful to have the strength to help his old friend get dressed and eat each day, which Whalley could no longer do alone. "I bless the Lord that gives me such a good measure of health and strength, and an opportunity and a heart to use it in so good and necessary a worke; for tho' my help be but poor and weak, yet that ancient servant of Christ could not well subsist without it, and I do believe, as you are pleased to say very well, that I do enjoy the more health for his sake."[188]

In his next letter, Goffe refers to Whalley as being "now with God."[189] Whalley was buried in Hadley, but the exact location remains a mystery. When Russell's house was razed in 1795, the scant remains of a body were found in what appeared to be a coffin underneath a large flat stone.

There was also found a swelling in the basement wall of Russell's house, suggesting that Whalley's grave was dug horizontally from the basement out of the necessity for secrecy.[190] While that scenario is plausible, Hadley historian George Sheldon questions its plausibility. Sheldon claims that after 120 years, a body would not have decomposed so much.[191] Among other traditions, a woman from Wethersfield, Connecticut, who had grown up in Hadley recalled a legend among the local girls that a body was buried on the property line between Mr. Tilton's lot and that of his father. In that way, each owner could maintain that Whalley was not buried on his property.[192]

In 1675, the small frontier town of Hadley became the front line in New England's second major Indian conflict, King Philip's War. Hadley, being on the frontier, was vulnerable to Indian attack. The entire Connecticut River Valley was reeling from a series of coordinated hit-and-run strikes on the river towns. In short succession, between June and October 1675, Swansey, Brookfield, Hatfield, Deerfield, North Hampton, Springfield, Suffield (in Connecticut) and Northfield were all attacked, and many burned, killing dozens.[193] Suddenly, as the headquarters for military operations, Hadley was overrun with troops from Connecticut and Massachusetts passing through. Reverend Russell was in charge of war correspondence with leaders between Boston and Connecticut.[194] In this dangerous and busy atmosphere, an interesting legend was born. The tradition was first documented in 1764 as literally a footnote in the larger regicide story written by Massachusetts Royalist governor and historian Thomas Hutchinson. It was first told to him as a legend of the Leverett family, whose ancestor John Leverett was Massachusetts governor during King Philip's War and spent time in Hadley. According to the story, on the afternoon of Sunday, September 1, 1675:

> *Hadley was alarmed by the Indians in 1675, in the time of public worship, and the people were in the utmost confusion. Suddenly, a grave elderly person appeared in the midst of them. In his mien and dress he differed from the rest of the people. He not only encouraged them to defend themselves; but put himself at their head, rallied, instructed and led them on to encounter the enemy, who by this means were repulsed. Just as suddenly, the deliverer of Hadley disappeared. The townspeople were left in consternation, utterly unable to account for this strange phenomenon.*

In time, this event would be referred to as the intervention of "the Angel of Hadley," with the implication that the "Angel" was William Goffe.[195]

The Angel of Hadley

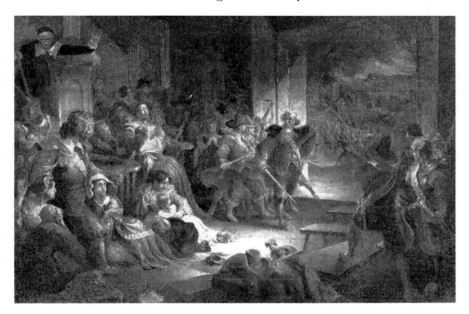

Frederic A. Chapman, *Perils of Our Forefathers*, circa 1850. *Courtesy of Forbes Library.*

That's not too far-fetched. Goffe, who was in fact an old man by the time the incident occurred, would not have been at the church service on Sunday; he was likely in his room in Reverend Russell's house. It is plausible that when he learned of the Indian attack and recognized the calamity about to take place, Goffe rushed out of the house in his home clothes and stormed the scene. Goffe, unrecognizable to many, dramatically took control in the chaos and efficiently organized and rallied the townspeople into an effective defense. If anyone was capable of such a feat, it was the old Roundhead colonel who had routed the Cavaliers across the battlefields of England time and again. With Goffe's help, the Hadley townspeople successfully repulsed the quick-striking natives and saved the town from being burned. Just as quickly as he arrived, Goffe vanished, not only to save his own skin from capture but also to protect those Hadley residents who knew of his concealment within their town. Since its original publication in 1765 by Massachusetts governor Thomas Hutchinson, the story has been retold and embellished in many variations.

Although possible, there are problems with the story, and its authenticity has been debated ever since its first appearance. For one thing, Hadley was not attacked on September 1, 1675, and there is no contemporary written

evidence of the "Angel" story. The primary and earliest account of the war, published by Reverend Increase Mather, only briefly states that on that date, while at church, Hadley residents experienced "a most sudden and violent alarm, which routed them the whole day after."[196] While this incident bears some semblance to the details of the Angel legend, no battle occurred that day. No other account even mentions Mather's "alarm."

Although Hadley was not involved in battle on September 1, 1675, it was attacked the following year, on June 12. Originally, this date was also ruled out as a possibility for the Angel's appearance because, in his history, Mather gives the impression that there were Connecticut soldiers in Hadley at the time and that they were the ones who successfully defended the town.[197] According to Mather, three soldiers were leaving the south side of Hadley's fortifications when they were set upon and mortally wounded by Indians. Mather creates the impression that this initial Indian attack was repulsed by Connecticut soldiers with his statement that "God in great mercy to those western plantations had so ordered by his providence, as that Connecticut Army was come thither before this onset from the enemy." Since then, other histories have offered similar accounts.[198] This story was technically true, as Connecticut soldiers had "come thither," but by June 12, the overwhelming majority had left Hadley four days earlier and were now based across the river in North Hampton, leaving only a few behind. Further, Mather does not explicitly state that it was the Connecticut soldiers who fought the Indians at Hadley. He goes on to say that there were also about two hundred friendly natives, allied with the English, in Hadley. It seems just as likely that it was these natives and remaining soldiers who turned back and chased the attackers south of Hadley for nearly two miles. Since Mather's book, historians for more than two hundred years have repeated this ambiguous version of events as truth.

However, the raid on the south side of town was just the first part of a two-pronged attack. Mather reports that, a mile away, at the opposite end of the fortifications,

> *a sudden great swarm of Indians issued out of the bushes and made their main assault at the north end of the town. They fired a barn which was without the fortifications, and went into a house, where the inhabitants discharged a great gun upon them, whereupon fifty Indians were seen running out of the house in great haste, being terribly frightened with the report and slaughter made amongst them by the great gun.*[199]

The Angel of Hadley

Hadley Green. This is a view of the mile-long Hadley Green, the site of an Indian attack during King Philip's War on September 1, 1676, the only plausible date for the legend of the Angel of Hadley to have taken place. *Private collection.*

Here, on the north end, it was the townspeople who repulsed the Indians. After a period of disarray and confusion, the firing of a "great gun," or cannon, turned the tide of the battle and saved the town.

If the "Angel of Hadley" story is true, this battle is most compatible with it. The sequence of events matches Hutchinson's initial version, except the date, and provides a plausible opportunity for Goffe's heroic deeds. Writing to Mather a year later, in 1677, Russell makes puzzling statements that lend further support to the Angel story, with June 12 as the date of its occurrence. Russell writes:

> *I find nothing considerable mistaken in your history, nor do I know whether you proceed in your intended 2d edition. That which I fear in the matter is least Mr. B. or some of Connecticut should clash with ours & contradict each other in the story as a matter of fact. Should that appear in print which I have often heard in words, I verily fear the event would be exceedingly sad.*[200]

This quote suggests that Russell had reviewed Mather's version of events and was concerned that his account would cause controversy.

If June 12 was the date of Goffe's supposed heroism, Russell was correct to worry about Connecticut soldiers contradicting Mather's version of events, as it made clear that they were not responsible for the English victory in Hadley that day. Russell also refers to a story that many spoke of but that had not been printed. This lends credence to the fact that that story had only been told orally before it was recorded by Hutchinson, and later by Stiles, more than ninety years after the fact. Russell had a right to be afraid if Goffe's life in Hadley was to be made public. The identity of the "Mr. B." to whom Russell refers can only be guessed at, but Lemuel Welles suspects it may have been Gershom Bulkeley. Bulkeley was a surgeon during the war and with the Connecticut troops at the time. In Wethersfield, Connecticut, Bulkeley had been not only the leader of an anti-Russell faction but also an ardent Royalist.[201] If ever there were someone whose name begins with a B who was likely to make trouble for Russell, it would be the litigious Bulkeley.[202] Bulkeley's superiors in the Connecticut forces were two of Russell's brothers-in-law, Major John Talcott and Captain Benjamin Newbury, and at this time, other influential leaders also had close ties to Goffe and Russell. The governor and deputy governor of Connecticut were none other than William Leete and Robert Treat, the two New Haven magistrates who previously had obstructed the search by Kirke and Kellond. Even Massachusetts governor John Leverett had served under Whalley's command as an officer during the English civil war.

Within weeks after the June 12, 1676 attack on Hadley, another of Charles II's agents in the region, Edward Randolph, wrote in England that he knew that "Goffe the Old Rebel is still in this Country" and that he had narrowly avoided capture in the southern parts, where he was harbored by "their Antimonarchicall Proselytes."[203] He may have been referring to the Hadley incident.

Clearly, if the Angel story is true, Hadley could no longer provide Goffe safe refuge, and he was once more in need of a new home. Nevertheless, even if the story is merely a myth, something happened around that time to force Goffe from town after twelve years. Within two months of the battle in June 1676, the Reverend Samuel Nowell, a chaplain who had been in Hadley the previous April, helped Goffe to relocate south to Hartford, Connecticut, where he was taken in by the Bull family. Something else must have happened in Hadley to warrant his relocation after twelve years.

CHAPTER 14

"MY AFFLICTION HATH BEEN FOR MY GOOD"

In Hartford, Goffe assumed the alias T. Duffell and lived in peace for perhaps four years. As in each of the other New England towns Goffe had called home, though, he could not avoid detection from suspicious pursuers. In about 1678, Goffe had to make one final escape, following a pattern that must have seemed dishearteningly familiar to him. On this occasion, it was a disgruntled soldier from King Philip's War named John London of Windsor, Connecticut, who tried to apprehend the old soldier. London had previously been imprisoned by Governor Leete for leaving the army without permission and slandering officers. London knew that Goffe had been living with Bull for several years and went with his friend Robert Howard to Bull's house, where they saw Goffe in person. They claimed to recognize Goffe from their days in England. London then conspired with his neighbor, Thomas Powell, to seize Goffe. Powell backed out of the arrangement, so London prepared to act alone the following Monday.

But at daybreak on Sunday, Powell, with the marshal, whose last name was Graves, woke London and insisted he come to Hartford to the houses of John Talcott and John Allen. Talcott and Allen were veteran officers of King Philip's War and each influential Connecticut officeholders. Talcott had been treasurer of the colony until he resigned to fight in the war. He was also one of the patentees and holders of the Connecticut Charter of 1662. Allen was currently serving as secretary for the colony. At Allen's house, they read Powell's testimony about London's plan. Talcott and Allen were apparently angry that London was planning to libel the Connecticut colony

in neighboring New York. London was permitted to leave the meeting, but the next day, Talcott and Allen, among others, showed up on London's doorstep in Windsor, ordering him not to leave the colony. London then told the men that he knew where Goffe was hiding. The men replied that Goffe had died long ago and charged London with being a traitor to the colony, declaring that he deserved to be hanged for conspiring against them. London, under the excuse of needing to obtain a horse, eventually fled the colony and succeeded in providing an affidavit about Goffe's presence in Hartford to Sir Edmund Andros, the governor of New York.

Andros was slow to act on London's account. Andros apparently did not trust London but nevertheless felt obliged to act on the matter and inform Connecticut officials of the accusation and compel them to act. In his letter to Connecticut governor Leete, Andros writes:

> *Honorable Sirs.—*
> *Being informed by depositions taken upon oath that Colonel Goffe hath been and is still kept and concealed by Captain Joseph Bull and his sons in the town of Hartford under the name of Mr. Cooke said Goffe and Colonel Whalley (who is since dead in your parts) having been pursued as traitors, that I may not be wanting in my duty, do hereby give you the above intimation, no ways doubting of your loyalty in every respect and remain honorable sirs. Your affectionate neighbor and humble servant.*
> *E. Andros. New York May 18ᵗʰ 1680.*

Leete received the letter on June 10, 1680. He wrote a warrant for the search and arrest of Goffe, but he was not found. His quick action was probably a reflection of his confidence that Goffe was no longer in town.

By this time, it is likely that Goffe was not actually in Hartford. During these years, Goffe's letters to friends and family become less and less frequent. He wrote of his "weakness" to his longtime friend Increase Mather. With the passing of his friend William Hooke, Goffe's wife, Frances, was now living in a new location but had failed to give her husband her new address. In his final known letter to Increase Mather, on April 2, 1679, Goffe expresses his longing to hear from his "poor desolate relations" and know if his last letters, which were sent without an address, got through to them.[204] Upon reflection on his long and trying life, Goffe wrote, "Not any one ingredient which my tender-hearted and wise father hath put into my cup could have been spared, my affliction hath been for my good."[205]

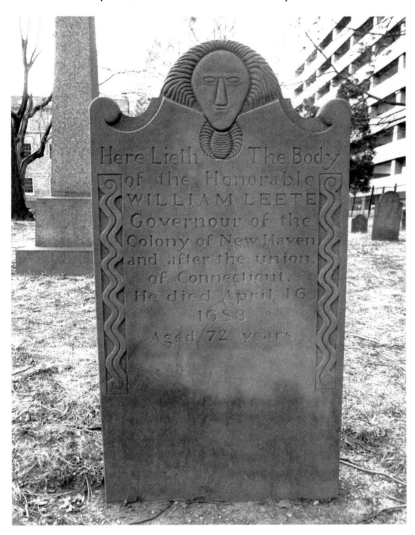

A reproduction of the gravestone of Governor William Leete, who was buried in the Ancient Burying Ground in Hartford, Connecticut. Leete protected William Goffe from capture on two occasions, first as governor of New Haven in 1661 and second as governor of Connecticut in the late 1670s. *Private collection.*

Though there's much speculation as to where Goffe lived out his final few years, it is most likely that Goffe spent his last days back in Hadley, among the people who had provided for his safety for more than ten years and near the resting place of his dear friend Edward Whalley. After his death, Goffe's papers were given to Reverend Increase Mather from that location.

CHAPTER 15
THE OTHER REGICIDE
JOHN DIXWELL

With the passing of Whalley and Goffe, a single regicide, John Dixwell, remained in New England. After visiting Whalley and Goffe in Hadley back in 1665, it is likely that he headed south to Connecticut. Because neither the Crown nor any other Royalists knew of Dixwell's whereabouts, he was able to forge a long and quite normal life in New Haven under the alias James Davids.

In England, Dixwell had worked in different circles than Whalley and Goffe. He was from a different region, born at Coton Hall, Warwickshire, to Edward and Mary Dixwell. It appears likely that he was raised by his uncle, Sir Basil Dixwell, in Kent. John Dixwell was educated at Lincoln's Inn beginning in 1631 and was called to the bar in 1638. In the middle of the civil war, upon his brother Mark's death, Dixwell inherited a substantial estate in Kent and the custody of his brother's children. While he was active in the parliamentary cause, Dixwell's contribution to the war effort was not primarily on the battlefield. He served on the Committee of Sequestrations for Kent, charged with the confiscation of Royalist estates. In the 1646 Parliament, Dixwell represented Dover, aligning himself politically with the Independents, who were well represented in the army. However, unlike Whalley and Goffe, Dixwell was motivated primarily by a commitment to republican government. Although he was certainly a religious man, Puritanism does not seem to have played the central role in Dixwell's life that it did for Whalley and Goffe.

As an MP, Dixwell received many prestigious appointments, including membership in the Committee for Plundered Ministers, which was

responsible for silencing clergy who were loyal to Charles I. He was also on a navy committee. In 1648, Dixwell served on the High Court of Justice, where he conscientiously attended most meetings and did not miss a single day of Charles I's trial. His willing participation in the trial, as demonstrated by his exemplary attendance, is in contrast with an account made at the trial of fellow regicide John Downes. In his defense, Downes claimed that he disapproved of Charles's death sentence and that he had spoken out against it during the trial. He also knew of several others who were "much unsatisfied, yet durst not speak," including Dixwell.[206] Without their support, Cromwell personally pressured Downes to acquiesce, and without the support of others, he had little choice but to sign the death warrant. Dixwell's name appears on the warrant, and there has never been any other evidence supporting Downes's claim. Taking Downes's defense into consideration, the court imposed a reduced sentence of life imprisonment in 1660.

During the political struggles following Charles's death, Dixwell survived Colonel Pride's Purge of Parliament. He was a member of Cromwell's Council of State in 1651–52, where he was active in matters concerning the navy. He left the council to become governor of Dover Castle. Dixwell did not support the creation of Cromwell's Protectorate, but he did willingly

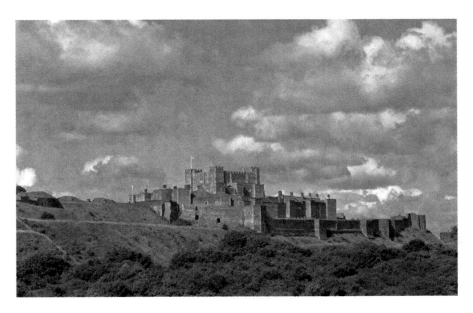

Dover Castle. *Courtesy of Dover District Council.*

serve in the Parliaments of 1654 and 1656 during the Cromwell regime. After Cromwell's death, Dixwell was recalled to Parliament in the second assemblage of the Rump of 1659 and again elected to the Council of State under Richard Cromwell. With Richard's fall from power, Dixwell held Dover Castle for the republican faction. After Parliament ordered the arrest of the regicides, a relative petitioned the House of Commons to allow Dixwell to turn himself in late on account of Dixwell's poor health. His

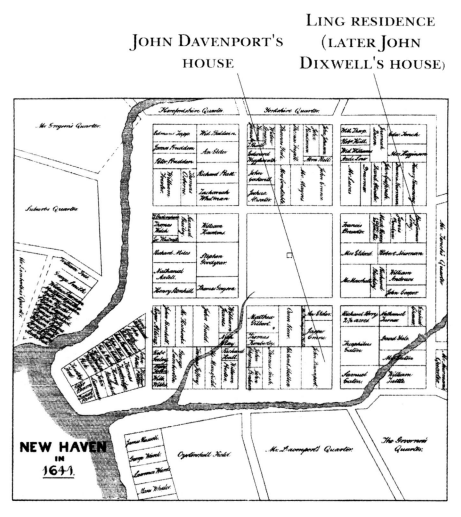

This early New Haven map (1641) shows the location of the houses where Whalley, Goffe and Dixwell were secreted. *Courtesy of the New Haven Museum.*

petition was granted, but his health was not poor. He was rushing to sell off parts of his estate before fleeing to Hanau, Germany. The next time he was heard from was on the doorstep of Reverend Russell's house in Hadley, Massachusetts, in 1665.

Likewise, Dixwell had a different support network in New England, though he must have relied on some of the same sympathetic men who helped Whalley and Goffe. Reverend Increase Mather, for instance, relayed messages for Dixwell as he had for the other judges.[207] However, Dixwell also received letters through New York. After departing Hadley, Dixwell eventually arrived in New Haven, although there is no account of when or how he got there. But once in New Haven, Dixwell was hosted by an elderly childless couple named Benjamin and Joanna Ling, whose house stood on the corner of where Grove and College Streets are today. Benjamin Ling was an original settler of New Haven, arriving with Governor Eaton from Charlestown, Massachusetts, in 1640. In 1673, Benjamin Ling died, leaving most of his property to his wife. Joanna Ling married Dixwell, who was then known as James Davids, on November 3, but she passed away within a month after the ceremony.

Not surprisingly, Dixwell shunned employment and social interaction in New Haven. Residents frequently wondered about the quiet, mysterious man who seemed to have clothes and books above the normal social class.[208] Likewise, William Jones, in whose house Whalley and Goffe had previously stayed, claimed to have recognized Dixwell from their time together at Westminster in London. According to the Reverend James Pierpont, Dixwell's "wisdom and great knowledge in the English law, state policy and European affairs made his conversation very valuable" and gave Dixwell an honorable reputation.[209] It is certainly true that Dixwell was well read. Many of his letters involve the exchange of books from his library that were scattered in various hands.

Like Whalley and Goffe, Dixwell received financial and material support from relatives abroad. Dixwell's niece Elizabeth Westrowe, with whom he kept in frequent contact, sent him money on several occasions, including twenty pounds as late as 1685, a time when Dixwell's New Haven house was valued at sixty-five pounds. She also sent things such as books, cloth, shirts, buttons and other small wares.[210]

Nearly four years after Joanna passed away, Dixwell, now about seventy years old, remarried. With his new wife, Bathsheba, who must have been substantially younger than Dixwell, the couple had three children: Mary

in 1679, John in 1680 and Elizabeth, who died young, in 1682. During the last years of his life, much of Dixwell's correspondence involves his desire to secure his English estate for his children. Through the execution of deeds and trusts, Dixwell hoped his son, John, and/or his two daughters, out of love and affection, would inherit the bulk of the property. The £13,000 estate included a priory in Folkstone, Kent, farms in Houghton, Sandgate and Buckland and other properties.[211]

In 1685, Dixwell, now about seventy-eight, was admitted membership into the church at New Haven. But even as he continued to integrate himself with the New Haven community, his letters reveal that he always held out hope of returning to Europe. A letter from Elizabeth shows that Dixwell may have considered leaving New Haven in 1678. "When you have any thoughts of coming into Holland let me know & if I can I will meet you for I long to see you: for I find no such friends now as you were to us," she wrote.[212] Other letters, very lengthy, include detailed news from abroad. Whalley and Goffe had always intended to return to England, viewing the restoration of the king as only a temporary setback in the larger Puritan plan. Dixwell expressed his confidence that "the Lord will appear for his people, and the good old cause for which I suffer, and that there will be those in power again who will relieve the injured and oppressed."[213] Dixwell nearly lived to see a day when a return could be possible.

Yet in 1685, New England's worst political fears were realized. After the death of Charles II, his authoritarian Catholic brother James II took the throne and advanced his brother's interest in consolidating the colonial governments. In New England, at the end of 1686, Governor Sir Edmund Andros arrived as the governor of the newly created Dominion of New England, a consolidation of Massachusetts, Plymouth, Connecticut, Rhode Island, New York and New Jersey colonies. His orders included aligning colonial laws with those of England and breaking the religious intolerance of the Puritans. This turn of events certainly did not bode well for Dixwell's chances of a return to England. Andros requested that each colony turn over its former charters, but Connecticut, stubbornly seeking to protect its cherished autonomy, refused. On October 27, 1687, Andros came to Hartford to conduct business and to personally seize the state's charter. He and the Connecticut authorities met in the public meetinghouse and discussed Andros's commission, after which the time came to submit the charter. As tradition holds, the charter was brought out and placed on a table in the center of the room, when suddenly the candles were extinguished

and the meetinghouse went dark. In the moments before the candles could be relit, Joseph Wadsworth dashed the charter off the table, ran it out of the meetinghouse away from the clutches of the royal governor and hid it safely in the hollow of an enormous white oak tree. Andros may not have succeeded in confiscating the charter, but his royal governmental policies continued to be implemented.

The dark state of affairs during James II's reign came to a head in England with the birth of a son, also named James, to the royal couple, which raised the prospect of a permanent Catholic monarchy in England. At the invitation of Englishmen, a Dutch invasion force led by William of Orange landed in England and overthrew James II. William was married to Mary Stuart, a Protestant and the former heir apparent. This relatively bloodless coup was later dubbed the Glorious Revolution. In the Dominion of New England, colonists celebrated by imprisoning Governor Andros, arresting his officers and reinstating their former charters. Andros was later sent packing back to England. With the Protestant William and Mary in power, the time now finally seemed right for Dixwell's return to his native land. On September 23, 1689, his friend in England Thomas Westrowe

Gravestones of Bathsheba and Mary Dixwell, Ancient Burying Ground, Middletown, Connecticut. *Photography by Nicole Marino, private collection.*

wrote that he was optimistic that he could secure a pardon for Dixwell from the new king and Parliament and that Dixwell and his family should leave for Amsterdam as soon as possible.[214]

Unfortunately, Dixwell had died of edema (then called "the dropsy") only months before, on March 18, 1689. (Dixwell may never have made a successful return to England at any event. When fellow regicide Edward Ludlow tried to return from Switzerland, an order was made for his arrest, and he was forced to flee.) Dixwell revealed his true identity in his estate papers. In them, he entrusted William Jones, James Pierpont, James Bishop and Reverend Samuel Hooker (of Farmington, Connecticut) to look after his family if friends Elizabeth and Thomas Westrowe could not. Five other men were listed as witnesses; this shows the minimum number of people who knew of his identity and location.[215]

Dixwell left his son his books, a silver standish, tweezers in a red tortoise-shell case and his sword and gun. To his surviving daughter, he left £12 and to his wife, Bathsheba, the remainder of his estate, which was worth a total of £276, including his house and land. After his death, Dixwell's son, John Jr., and daughter Mary began to use the name "Dixwell." John married Mary Prout of New Haven, with whom he had two sons and a daughter. He moved to Boston and became a noted goldsmith. He never succeeded in acquiring his father's English estate. Mary married John Collins of Middletown and had six children. She died in 1727 and is buried in that town.[216] John Dixwell's grave is located behind the Center Church on New Haven Green.[217]

CHAPTER 16

WHALLEY, GOFFE AND THE AMERICAN REVOLUTION

During the era of the American Revolution, the regicides were popular figures. Historian Ezra Stiles, who lived during the period, reports that during the French and Indian War, English soldiers declared of John Dixwell's grave that "if the British ministry knew of it, they would even then cause it to be dug up and vilified." Stiles goes on to say, "Often have we heard the Crown Officers aspersing and vilifying them; and some so late as 1775 visited and treated the grave with marks of indignity too indecent to be mentioned."[218] Conversely, on their journey to the First Continental Congress in Philadelphia in 1774, John Adams, Samuel Adams, Thomas Cushing and Robert Treat Payne (the four who composed the Massachusetts delegation) stopped to visit at the graves of the regicides. Their journey through Connecticut was described as a triumphal procession, with many residents cheering the men at the roadside. A brief stop to pay homage at the grave of John Dixwell as part of their tour of the town was suitable, considering the work the men would soon conduct in Philadelphia.

Whalley and Goffe were also assigned prominent roles in two early histories of the colonies. Interestingly, the two accounts exploit the elusive nature of the story of Whalley and Goffe to promote their respective political sympathies during the contentious time of Revolutionary politics. Professor Mark Sargent's careful analysis juxtaposing the histories of Thomas Hutchinson and Ezra Stiles reveals opposite agendas, each backed by differing research styles. Hutchinson was the Royalist governor of Massachusetts from 1769 to

John Dixwell's monument and gravestone (foreground), New Haven Green. *Private collection.*

1774 and Stiles a Congregational minister and president of Yale University from 1778 to 1795.

Although they did not know it for many years, the two honorable men were compiling resources for separate projects on the same topic: the history of the settlement of New England. Both men amassed important libraries of primary sources. Hutchinson's library in particular was regarded as unparalleled on the subject. Tragically, for Hutchinson personally and historians academically, Hutchinson's mansion was stormed and nearly razed in an attack by the Boston mob in 1765 as part of the Stamp Act protests. Hutchinson was serving as lieutenant governor at the time. Not only was his house literally destroyed, but his library, filled with original documents, was also raided by the rioters, leaving pages actually blowing in the street the following morning. Fortunately, no lives were lost, but the diary that William Goffe kept between 1660 and 1667 was a historical casualty. Hutchinson was the first to finish. The first volume of his *History of Massachusetts Bay*

was published in 1764 and included information about the regicides. The volume contains the only and last shreds of information from the destroyed original documents.

As Professor Sargent notes, "Hutchinson read his own loyalty to George III back into New Englanders' attitudes toward the Stuarts."[219] Hutchinson cited key events in the lives of Whalley and Goffe as evidence of a heritage of loyalty. In his *History*, Hutchinson preferred to take events at face value. He believed Governor Endecott acted as quickly as possible and Governor Leete acted in good faith. He spared Whalley and Goffe his harshest criticism when describing their role in the king's execution and saw little wrong with Boston's warm welcome to the judges upon their arrival. After all, Whalley and Goffe were not wanted men at that point. Once Massachusetts officials learned of the proclamation for Whalley and Goffe's arrests, Hutchinson recognized a complete turnaround in their actions. He emphasizes their vigorous pursuit of the men, which he says forced them to flee the colony into the wilderness in the dead of winter. Hutchinson excused colonial leaders for their inability to catch their men and likewise excused the populace at large. He uses the legend of the Angel of Hadley to prove his point. If the Hadley residents had known about Whalley and Goffe for more than ten years, why did they credit their rescue to an angel? This could only be because they must have had no idea who Goffe was. They could not be trusted with that information, for they would certainly have turned Goffe in, Hutchinson reasons. Of course, Governor Hutchinson himself was desperate to justify his own Loyalist sympathies in the explosive city of Boston in the 1760s, and he was claiming New England's history at this time as his own. Hutchinson may have been criticized for his actions as royal governor, but even his detractors respected the quality of his historical scholarship, which added to the legitimacy of his version of his events. In addition, only Hutchinson had access to Goffe's diary and other rare papers. But with those papers destroyed, other historians could not easily use them to counter Hutchinson's version.

One who tried was Ezra Stiles of New Haven. Writing in the early 1790s and knowing that he could not top Hutchinson's documentary resources, Stiles toured the New England countryside, exhausting every possible lead to garner clues that Hutchinson might have missed. Stiles interviewed the families of residents in the towns in which Whalley and Goffe had been sheltered one hundred years earlier. Seeking out the older generation of his day, Stiles strove to get as close as possible to the actual participants through

oral tradition. He recorded their family legends, no matter how far-fetched, and then researched them as best he could for validity. He visited the houses in which Whalley and Goffe stayed, recording layouts and measurements, gleaning any information he could as he chased their elusive legend from town to town. Predictably, Stiles's reliance on oral history yielded both gold mines and landmines. Whalley and Goffe stayed for a time at Hatchets Harbor, whose name would imply that the site was located on the ocean or a river, but Stiles learned that the word "harbor" was used to mean "refuge," drawing on local lore. He found that they likely camped at a spring on farmer Sperry's property for those two days, not at an actual harbor. Several stories, although possibly containing grains of truth, have been proven wrong. Nevertheless, Stiles's research was new and amusing and a valuable approach to research that complemented and amended Hutchinson's more traditional approach.

In *A History of Three of the Judges of King Charles I*, Stiles conceded the legitimacy of Hutchinson's argument that Whalley and Goffe did indeed need to remain hidden from the king's agents and much of the New England populace alike. But unlike Hutchinson's version, in which the New Englanders acted in the right and the judges in the wrong, Stiles arrived at the opposite conclusion. Instead, in his view, the English and New Englanders' moderation toward Charles II was a mistake. The New Haveners, who were not cowed by crown pressure and who did the most to protect their safety, were an important exception. It was only after the Glorious Revolution that the rest of New England was safe to embrace the men and their actions fully. For Hutchinson, the price of New England's Roundhead support during the English civil war was the responsibility for dealing, illegally, with the fugitive regicides afterward. Instead of castigating Whalley and Goffe for their fanatical Puritan beliefs that led to the illegal execution of their king, Stiles praised Whalley and Goffe's daring and their adherence to republican principles. The willingness of the English, and some New Englanders, to abandon the republican principles shared by Whalley and Goffe marked the beginning of a long degeneration of the English character and a deviation from the principles of the English constitution. This trend, Stiles believed, culminated in the Age of Revolutions.

This interpretation of history was characteristic of the time. During the Revolutionary period, John Adams similarly contended that the colonies were the true upholders of the time-honored English liberties and it was in fact the English themselves who were rebelling.[220] At the very time that Stiles was writing his *History*, in 1792, the French were fighting their own

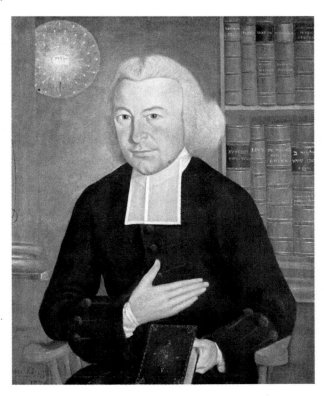

Ezra Stiles. *Courtesy of Yale Art Gallery.*

revolution. In Stiles's version of the Angel story, New Englanders concocted the story to protect Goffe's identity. They sought to protect him because they honored the values for which he stood.

Stiles and Hutchinson knew the power history holds over the minds of men, and both were eager to claim it. Hutchinson used the story of the regicides to show that his own present Loyalist stance was merely the most recent development in a long history of the loyal colony. He was positioning those who resisted the Crown as deviants who were abandoning Massachusetts's loyal heritage. Stiles, on the other hand, sought to interpret New England's history with an eye toward the future. He anticipated the "vindication" of the political actions and beliefs of Whalley and Goffe during the Age of Revolutions of his own time. While the research and narratives produced by Hutchinson and Stiles represented only a small front in a much larger war of ideas during the Age of Revolutions, their work served another important role as a source of information and inspiration for the new Romantic literature for the next half century.

CHAPTER 17
THE ROMANTIC REGICIDES

In the decades after the American Revolution and the War of 1812, with nationhood firmly established, ambitious Americans were eager to attend to the business of America. In time, virgin fields were put under the plow, canals were built and miles of railroad tracks were laid. Yet the new nation lacked a cultural identity, and American writers and artists sought to define and express what the term "America" meant. When compared with ancient countries such as England and France, the United States seemed to lack the cultural heritage that legitimized the great countries of the world. The process of building such a heritage took place during the Romantic era in the arts, literature and philosophy. Romanticism was largely a reaction against the values of classicism before it, and as such, the movement favored emotion and imagination over reason. Nature, a central theme, was valued less as a subject of scientific inquiry than as a source of connection to God and a place of refuge from the world's problems. Always rich with symbolism, Romanticism favored settings that were far away in both time and place.

Very early in United States history, artists searching for inspiration quickly diverted their attention away from the east to the vast, rich continent that lay to the west. Moving away from the classicism of Europe, a group of American artists instead developed a new distinctly American artistic movement known as the Hudson River School. Artists of this movement were inspired by what they viewed as the defining feature of the new nation: America's vast wilderness. The Hudson River artists used the landscape painting as a medium to communicate the unparalleled scale, diversity and

beauty of the American wilderness. Interestingly, many of the leading artists of the new nation were from Connecticut. This at least partially accounts for the choice of New Haven's West Rock and Judges Cave as subjects for artistic expression. The man viewed as the father of the Hudson School artists, Thomas Cole, was equally influential for both his pen and his paintbrush. If glorious nature was the setting, Hudson River artists sought to imbue it with the democratic spirit and Christian morality of the new young nation.

As Professor Christopher Kent Wilson notes, "The Hudson River painters were a powerful force in establishing a sense of national well-being and emotional yearning for social identity in the middle years of the century."[221] Early in 1836, Thomas Cole himself reflected on this dilemma. He wrote:

> *American scenes are not destitute of historical and legendary association—the great struggle for freedom has sanctified many a spot, and many a mountain, stream, and rock has its legend, worthy of the poet's pen or the painter's pencil. But American associations are not so much of the past as of the present and the future. Seated on a pleasant knoll, look down into the bosom of that secluded valley, begirt with wooded hills—through those enameled meadows and wide waving fields of grain, a silver stream winds lingeringly along—here, seeking the green shade of trees—there, glancing in the sunshine: on its banks are rural dwellings shaded by elms and garlanded by flowers—from yonder dark mass of foliage the village spire beams like a star. You see no ruined tower to tell of outrage—no gorgeous temple to speak of ostentation; but freedom's offspring—peace, security, and happiness, dwell there, the spirits of the scene. On the margin of that gentle river the village girls may ramble unmolested—and the glad school-boy, with hook and line, pass his bright holiday—those neat dwellings, unpretending to magnificence, are the abodes of plenty, virtue, and refinement.*[222]

Cole and his fellow Hudson River School painters were celebrating the wild, pure American wilderness for its beauty and promise. There could be no better place for the virtuous American farmer, viewed as the backbone of democracy, to make a good life.

Few settings better captured the spirit that Thomas Cole so eloquently described than West Rock in New Haven. Cole himself planned on painting the famous geologic landmark but did not find an opportunity to do so before, at the young age of forty-seven, he died. Cole's passing left the promising subject to his pupil, Hartford native Frederic Edwin Church. The year 1849

was a propitious one for Church to undertake the project, as it marked the bicentennial of Charles I's execution.

Church's rendering of *West Rock, New Haven* contained each of the three elements of a Hudson River School landscape. By this time, it was well known that West Rock was the home of the Judges Cave, where Whalley and Goffe had sought refuge on three different occasions from the king's searches. Their controversial role in Charles I's execution was being celebrated in America as a bold, Christian strike against the tyranny of the English monarchy. New Haven's legendary role in harboring the colonels was exactly the type of historical allusion Americans thirsted for at this time. Church's subtle placement of a church spire in front of the mountain was a reference to the important role of religion in the nation's past and future. The open expanse of the river, field, mountain and sky were all stunning reminders of America's natural beauty. The plaque commemorating Judges Cave on West Rock presents a quote commonly associated with American democracy: "Opposition to tyrants is obedience to God." These words, so fitting to the actions and motivations of Whalley and Goffe, are artistically depicted in Church's beautiful arrangement of church spire and mountain (the location of Judges Cave) in his painting.[223]

Frederic Edwin Church, *West Rock, New Haven*, 1849. It is part of the permanent collection of the New Britain Museum of American Art.

Church had completed two other works that communicated the themes of strength and democracy in early New England history: *Hooker and Company Journeying through the Wilderness from Plymouth to Hartford in 1636* (1846) and *The Charter Oak at Hartford* (1848). But it was *West Rock, New Haven* (1849) that was the seminal work in Church's promising young career. It was heralded as a "faithful, natural picture," in which Church had "taken his place, at a single leap, among the great masters of landscape." Shortly thereafter, Church was made a full member of the National Academy of Design, the youngest artist to ever be elected. After *West Rock, New Haven*, Church vaulted to the head of the Hudson River School, assuming the mantle formerly held by his esteemed teacher. He went on to be one of the most famous and richly compensated painters America had ever produced.[224]

Thomas P. Rossiter, another member of the Hudson River School, also took up the regicides as the subject of his work. Rossiter was born in New Haven and trained under local artist Nathaniel Joclyn. He was a quick study and established his own studio in New Haven by age twenty. Like Church, Rossiter was from a wealthy family and was well connected. Rossiter's social circle included John Frederick Kensett, Asher B. Durand and John Casilear, each of whom he traveled with at various times in Europe and the United States. Rossiter even accompanied Thomas Cole on a trip to Italy. Rossiter's friends may have been among the most accomplished painters of the Hudson River School, but Rossiter himself never committed fully to the movement. Instead, he preferred painting historical and religious subjects, through which he could communicate a story and personal sentiments. This view is expressed in a review of the 1855 Exposition Universelle he wrote for the American art periodical *The Crayon*, in which he noted: "Nine-tenths of the Exhibition was composed of [genre and landscape paintings] whose principal aim seemed the rendering of some picturesque effect, and the master of technical difficulties...Theme...seems of small consideration, or is but a hook on which to hang their skill. These studio qualities seen, the eye sought almost in vain for sentiment which touched the heart, and roused the mind into healthy suggestive reflection." His painting *The Regicide Judges Succored by the Ladies of New Haven* is a case in point. Rossiter returned from Europe in 1856, and it must have been then that he turned his attention to the legend of the regicides. Few subjects were better suited to communicate a narrative than the mysterious judges hiding in a cave in the wilderness. Rossiter's sympathy for the men is clear and takes precedence over the historical accuracy in the painting.

Thomas P. Rossiter, *The Regicide Judges Succored by the Ladies of New Haven*, 1876. *Courtesy of the New Haven Museum.*

Rossiter was better received in his own time than he is today. His most famous painting, the *Signing of the Constitution*, once hung prominently in Independence Hall in Philadelphia. It has since been taken down on account of some of the glaring historical inaccuracies it depicts. The same can be said of his regicide work. Rossiter's painting suggests a degree of openness between the regicides and local residents that never appears to have existed. The cave depicted bears little resemblance to the actual setting. Rossiter's critique of American landscape artists was eventually adopted and validated by critics later in the nineteenth century; nevertheless, his art fell out of favor, and sadly, he is primarily remembered as a travel companion to other, more prominent artists.[225] It is interesting to think that if Rossiter had valued historical accuracy a little more, rather than sentiment alone, at least one of his paintings might be more frequently displayed today.

Unlike Church and Rossiter, who benefited from professional study, world travel and family affluence, George Henry Durrie was largely self-taught and got his start by displaying his paintings in the window of his father's stationery store in New Haven. He began his career as a struggling portrait

artist. Though clearly a step above an itinerant portrait painter of his time, portraiture was not the area in which Durrie would make a name for himself. Over time, his curious mind led him away from portraiture, and he began to experiment with landscapes.

Largely rejecting the grand, expansive perspective of his contemporaries in the Hudson River School, Durrie painted summer landscapes and winter farm scenes. As Colin Simpkin observes in his short biography of Durrie, the angle of Durrie's landscapes "is wide enough to include all of the essentials, but the viewer still has the feeling that he is close enough to be within hailing distance." Durrie knew of and respected Frederic Church but incorporated only particular facets of Church's style into his own, which is difficult to classify. Simpkins continues, "The scenes are not static. Almost invariably there are people, calm and unhurried, going about their routine tasks of farm life." A consistent theme of Durrie's landscapes is the simplicity of life on the rural New England farm. These qualities are prominently displayed in Durrie's *West Rock, New Haven* (1853). It was during the 1850s that he began painting West Rock and East Rock with such frequency that they could be

George Durrie, *Judges Cave*, 1856. *Courtesy of the New Haven Museum.*

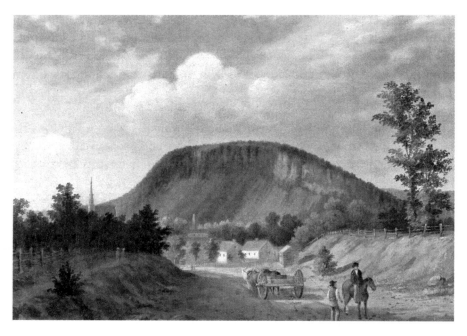

George Durrie, *West Rock, New Haven*, 1853. *Courtesy of the New Haven Museum.*

considered "bread and butter" work for him.[226] During this time, this work and a sister painting of East Rock were reprinted in lithograph form. In an advertisement for the prints, Durrie states, "They are the first objects looked upon by every New Havener with feelings of pride and satisfaction. What pleasure, then, would it not afford every citizen of New Haven, whether at home or abroad, to possess beautiful and perfect facsimiles of those charming spots." Durrie's chosen color scheme of pastel blue, bright gold, greens and salmon was characteristic of all his paintings and was likewise used in his 1856 painting *Judges Cave*. Unlike that of Frederic Church, Durrie's technique is not generally noted for its precision, yet it is Durrie who produced the most detailed painting of Judges Cave of the period.

Despite Durrie's success in his *West Rock, New Haven* and *Judges Cave* paintings, it was his winter landscapes of life on a rural farm that earned him a viable living and cemented his reputation in posterity. Durrie is the nineteenth-century artist most closely associated with winter landscapes. In 1861, only two years before Durrie passed away, famous printmakers Currier and Ives chose to publish lithographs of ten of his winter scenes, securing his legacy. "Perhaps he approached the farm scenes with a mind and eye trained

for portraiture and thus conveyed the character rather than just the physical aspects of rural New England. Without pretense or sophistication they have the rare quality of sincerity," Simpkins suggests.[227] Admirers have appreciated the evocative simplicity communicated by Durrie's brush ever since.

During the 1930s, Whalley and Goffe made a final appearance on the art scene, this time under vastly different circumstances. With the country in the throes of economic turmoil, artists, remarkably, were not left to fend entirely for themselves. When it was suggested that federal funding for the arts was frivolous during such a dire economic time, Harry Hopkins, Roosevelt's relief administrator, retorted that "[artists] have got to eat just like other people."[228] President Franklin Delano Roosevelt created a niche for artists under his vast program of economic relief called the New Deal, which most memorably included the Federal Art Project under the Works Progress Association. However, the Section for Fine Arts, a division of the Procurement Division of the Department of the Treasury, began providing some economic relief to artists in 1934, a year before the Federal Art Project. The Section for Fine Arts was charged with selecting fine art to decorate public buildings. The selection process was rigorous. Artists first submitted drawings to a selection panel, where they vied for commissions based on idea, ability and execution. Local themes and uplifting technique were strongly preferred. Once the artists received the commissions, they then needed to work closely with the local community for final approval of designs.

Artists were not selected based on need but on the basis of their ideas. Karl Anderson, for example, was a successful impressionist artist from Westport, Connecticut, who was chosen to paint a mural in the Westville Post Office of New Haven. Anderson grew up in Ohio in the late nineteenth century. In his early career, he produced illustrations for many prominent magazines, including *Vanity Fair*, *Scribner's* and the *Saturday Evening Post*. Seeking to move from illustration into the fine arts, Anderson studied at the Art Institute of Chicago and later entered art schools in Europe. Anderson and a small group of fellow Americans formed an art colony called the Giverny Group, which studied at Giverny, France, while Claude Monet was there. Members of the group gained prominence as leaders of American Impressionism from their highly acclaimed exhibition in 1910 at New York's Madison Gallery. Anderson's work is noted for his portrayal of figures, primarily women and children, in scenes of outdoor family life. He is perhaps best known for his depictions of women drinking tea. His technique is praised for his delicate rendering of light and color made more powerful through his use of heavy impasto (thick layers

of paint). Anderson returned to the United States in 1910, ultimately settling in Westport, Connecticut, where he headed an art colony.

From 1931 to 1943, Anderson taught at the Academy School in Westport, offering art classes while concurrently exhibiting his own work in New York. It was during this time that Anderson won the commission to paint the mural *Pursuit of the Regicides* (1939) at the Westville Post Office in New Haven. The

Karl Anderson, *Pursuit of the Regicides*, 1939. Westville Post Office, New Haven, Connecticut. *Private collection.*

This detail from Karl Anderson's *Pursuit of the Regicides*, 1939, shows John Davenport and two New Haven residents visiting the regicides at West Rock. *Private collection.*

In this detail from Karl Anderson's *Pursuit of the Regicides*, 1939, a Native American spies Edward Whalley and William Goffe living in a cave on West Rock. *Private collection.*

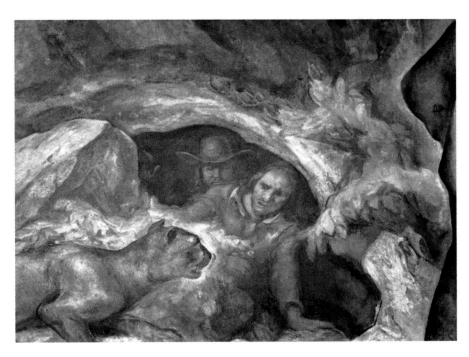

This detail from Karl Anderson's *Pursuit of the Regicides*, 1939, shows Edward Whalley and William Goffe surprised by a prowling cougar while living in a cave of West Rock. *Private collection.*

mural is a prime example of American Scene Painting typical of the post–World War I period. A reaction against the abstract style of the modernist movement of Europe of the time, American Scene Painting is characterized by a relatively naturalistic, realistic and descriptive style that communicates nationalism and romanticism of American life. Other famous American Scene Painters are Edward Hopper and Norman Rockwell. Anderson's *Pursuit of the Regicides* depicts various aspects, both fact and myth, of the regicide story. To the left is a Native American spotting the regicides at Judges Cave, presumably before they fled New Haven for good to Hadley, Massachusetts. In the center is the unsubstantiated legend of Whalley and Goffe being frightened out of their cave by a mountain lion. Anderson's cave is far more cavern-like, as opposed to the pile of leaning rocks that the shelter actually comprised. To the right is a scene recognizing the role New Haven residents played in concealing the men. Two of the citizens are anonymous, but the third is clearly Reverend John Davenport, the man most closely associated with Whalley and Goffe's stay in New Haven.

The journey of Whalley and Goffe had many features that made it a prime source of inspiration for literature in the Romantic period as well. Their narrow escapes and secret rendezvous had all the drama of a great story. The Angel of Hadley legend introduced a mysterious supernatural element that was popular at the time. Best of all, their story was barely documented, allowing plenty of room for embellishment and deviation. In the early nineteenth century, France was in the middle of violent and bloody revolutionary chaos, which caused readers and writers alike to think twice before giving unmitigated praise for the Puritan executioners. Nevertheless, the regicides became a common motif in the literature of the era, used in no fewer than eleven novels, including several by the most prominent authors of the time, between 1822 and 1850.[229]

Sir Walter Scott incorporated the story of the Angel of Hadley into his 1822 novel *Peveril of the Peak*. The story, based in England, featured two old civil war heroes, Sir Geoffrey Peveril, a cavalier, and Major Bridgenorth, a Roundhead, who have since reconciled their differences. When their children secretly fall in love, the young couple's marriage is prevented when Sir Geoffrey and his son are implicated in a plot to kill the king. In a conversation with Julian Peveril, Sir Geoffrey's son, Major Bridgenorth tells a story of his travels in New England. Bridgenorth was present during the attack on Hadley and witnessed Goffe's heroism firsthand. He used the story to exemplify the point that national emergencies sometimes bring out

the best in a nation. "Thou seest, young man," Bridgenorth explains to Julian, "that men of valour and of discretion are called forth to command in circumstances of national exigence, though their very existence is unknown in the land which they are predestined to deliver."[230]

In general, Scott stuck to the facts of the Angel of Hadley story, essentially reciting the basic narrative, with only a few errors (he confused Goffe with Whalley, for instance).[231] It is difficult to ascertain exactly whose version of history Scott used when writing *Peveril of the Peak*. He may have initially learned of the story from his American friend Washington Irving. His narrative, written in only about two thousand words, offers no particular features that point to a specific historian.

In *Peveril of the Peak*, Scott never quite answered the question of whether it was Goffe or an actual angel that saved the small frontier town. This supernatural element is why the book is credited as being the first fully Romantic account of the event.[232] Scott's popularity and that of his novels raised awareness of the legend, which would come to be embraced by other writers.

In 1829, James Fenimore Cooper's *The Wept of Wish-ton-Wish* featured a main character based on Goffe and the legend. The story takes place in the frontier town of Wish-ton-Wish (supposedly Native American for whippoorwill), located outside seventeenth-century Hartford. Captain Mark Heathcote, a widowed father, meets a mysterious stranger who was caught killing one of his sheep. After a long and private conversation, the stranger mysteriously disappears. When Wish-ton-Wish is attacked by hostile Indians, the stranger, now called Submission, helps rescue the family from the flames of the burning village. In the ferocity of the attack, however, little Ruth, Heathcote's granddaughter, is captured by the natives and is known henceforth as the Wept of Wish-ton-Wish. Throughout the remainder of the story, Submission (Goffe) plays the role of a mediator between the English and the natives during King Philip's War. The character of Submission is clearly inspired by William Goffe, as evidenced by key parts of the storyline. Shortly after Heathcote meets Submission (at which point Submission is known as "the stranger"), for instance, four brash English agents search the town in pursuit of a regicide. But the narrative of the story also differs greatly from Goffe's fugitive experience. After an Indian attack, Submission goes on to act as an intermediary between the two groups.

In 1837, Nathaniel Hawthorne wrote "The Grey Champion" as the opening short story of the compilation *Twice-Told Tales*. Like Scott,

This illustration from James Fenimore Cooper's 1829 *The Wept of Wish-ton-Wish* shows the character Submission defending the family of Captain Mark Heathcote from a ferocious Indian attack. *Courtesy of Watkinson Library, Trinity College.*

Hawthorne depicted Goffe as a deliverer, but in "The Grey Champion," Goffe delivered New Englanders from the grip of the hated John Andros, governor of the Dominion of New England. When the Bostonians heard of King William's overthrow of James II, the citizens cried, "Oh! Lord of Hosts, provide a Champion for thy people!" Goffe miraculously appeared. Dressed in old, outdated clothes and with a staff in hand, the elderly soldier stood firmly in the way of Andros and his advancing soldiers.

"Are you mad, old man?" demanded Sir Edmund Andros in a loud and harsh tone. "How dare you stay the march of King James's Governor?"

"I have staid the march of a King himself, ere now," replied the gray figure, with stern composure. "I am here, Sir Governor, because the cry of an oppressed people hath disturbed me in my secret place; and beseeching this favor earnestly of the Lord, it was vouchsafed me to appear once again on earth, in the good old cause of his Saints. And what speak ye of James? There is no longer a popish tyrant on the throne of England, and by to-morrow noon, his name shall be a by-word in this very street, where ye would make it a word of terror. Back, thou that wast a Governor, back! With this night, thy power is ended—to-morrow, the prison!—back, lest I foretell the scaffold!"

In response, Andros eyed the crowd of hostile Bostonians and again confronted Goffe, who stood immediately ahead of him in the road. Perhaps sensing the danger of moment, Andros ordered the slow retreat of his men. He was later arrested and the former governor restored. And what happened to the "the old rounded headed dignitary"? Some said they saw him, but after a moment he "faded from their eyes, melting slowly into the hues of twilight, till, where he stood, there was an empty space." But be not afraid, Hawthorne advised, for the hour of the Grey Champion was one of darkness, adversity and peril. And "should domestic tyranny oppress us, or the invader's step pollute our soil, still may the Grey Champion come."

CHAPTER 18
REGICIDES TODAY

In terms of public and academic attention, the story of Edward Whalley and William Goffe has come full circle. Once they had arrived in New England, their former status as Englishmen of prominence disappeared, and they were forced to retreat to the shadows and corners of colonial life. After their death, their story grew to become a popular, important and even hotly debated topic in the early years of the newly formed United States. But the regicides' presence on the radar of American consciousness has been in steady decline ever since. Today, their story has once again devolved to its original status in the late seventeenth century: elusive and undocumented. The most prominent reminders of their saga today are the names of three primary thoroughfares that traverse New Haven: Whalley Avenue, Dixwell Avenue and Goffe Street. Beyond these street names, their story is only kept alive by the local trails on which hikers can follow in the footsteps of the Old Cromwellians. It is easy to imagine the conversations shared by hikers as they try to piece together the lore behind the trail names. Otherwise, Whalley and Goffe are occasionally mentioned as footnotes in academic journals pertaining to other, larger subjects, much as the Angel of Hadley legend was first introduced in Hutchinson's first volume.

It should not be forgotten that the "Good Old Cause" for which Whalley and Goffe fought had a profound influence on the birth and early development of the New England colonies. Whalley and Goffe—and Dixwell—made a sound decision in coming to New England to seek refuge from Royalist ire. Their decision paid off, with all three men successfully evading to the

Regicides Today

Among the few modern reminders of the regicides' story are names of three major thoroughfares in New Haven, Connecticut: Whalley Avenue, Dixwell Avenue and Goffe Street. The streets were named after the three regicides in the nineteenth century. *Photography by Nicole Marino, private collection.*

last the king's attempts to apprehend them. The Restoration politics that complicated the harboring of Whalley and Goffe illustrates New England's complex relationship with the English Crown from the very beginning. This origin determined the initial trajectory of New England government and played out right up and through the American Revolution. The efforts of Thomas Hutchinson and Ezra Stiles to claim the regicide story for their own ideologies show that they understood Whalley and Goffe's importance to the development of democracy in England, the United States and around the world. The story of Edward Whalley and William Goffe was important to the people we deem important as America's founding fathers.

These men did not leave many material items behind; a Bible, a chair and a snuffbox are a few of the items attributed to the men. Even those items, like the men themselves, are shrouded in mystery. This is fitting because Whalley and Goffe were men whose minds were unconcerned with material possessions; rather, they were consumed by ideals, both religious and political. The legacy of Edward Whalley and William Goffe is their significant contribution, for better and worse, to the ideological and cultural heritage of the United States.

NOTES

Introduction

1. Adams and Thompson, *Revolutionary Writings of John Adams*, 32–33.

Chapter 1

2. Durston, "Whalley, Edward."
3. Phillips, "William Goffe," 717–20.
4. Durston, "Goffe, William."
5. Clary, "Hot Protestants."
6. Bremer, *Puritan Experimen*, 2.
7. Ibid., 31.
8. Ibid., 42.

Chapter 2

9. Dexter, *Memoranda*, 4.
10. Plant, "British Civil Wars."
11. Griffin, *Blood Sport*, 95.
12. Coward, *Stuart Age*, 200.
13. Ashley, *Battle of Naseby*, 16.

CHAPTER 3

14. Durston, "Goffe, William."
15. Durston, "Whalley, Edward."
16. Carruthers, *English Civil Wars*, 64.
17. Ibid., 68.
18. Dexter, *Memoranda*, 5.
19. Ibid., 4.
20. Carruthers, *English Civil Wars*, 135.
21. Fraser, *Cromwell, Our Chief of Men*, 125–32.
22. Gaunt, *Oliver Cromwell*, 45.
23. Kishlansky, *Rise of the New Model Army*, 32.
24. Plant, "British Civil Wars."
25. Fraser, *Cromwell, the Lord Protector*, 160.
26. Gaunt, *Oliver Cromwell*, 52.

CHAPTER 4

27. Dexter, *Memoranda*, 5.
28. Ashley, *Battle of Naseby*, 100.
29. Ibid., 117.
30. Gaunt, *Oliver Cromwell*, 61.
31. Durston, "Whalley, Edward."
32. Ashley, *Battle of Naseby*, 118.
33. Welles, *History of the Regicides*, 14.
34. Ashley, *Battle of Naseby*, 121.
35. Glover, "Putney Debates," 48.
36. Ibid., 48.
37. Ibid., 71.
38. Durston, "Goffe, William."
39. Glover, "Putney Debates," 72.
40. Ibid., 61.
41. Durston, "Goffe, William."
42. Ashley, *Battle of Naseby*, 124.

CHAPTER 5

43. Gaunt, *Oliver Cromwell*, 70.
44. Durston, "Goffe, William."

45. Crawford, "Charles I," 54.
46. Ibid., 41.
47. Kishlansky, *Monarchy Transformed*, 180.

CHAPTER 6

48. Ibid., 181.
49. Ibid., 184.
50. Underdown, *Pride's Purge*, 118.
51. Wedgwood and Rowse, *Coffin for King Charles*, 40.
52. Ashley, *Battle of Naseby*, 142.
53. Wedgewood and Rowse, *Coffin for King Charles*, 122.
54. Ibid., 123.
55. Ibid.

CHAPTER 7

56. Durston, "Whalley, Edward."
57. Durston, "Goffe, William."
58. Carruthers, *English Civil Wars*, 332.
59. Durston, "Whalley, Edward."
60. Ibid.
61. Kishlansky, *Monarchy Transformed*, 201.
62. Durston, "Whalley, Edward."

CHAPTER 8

63. Kishlansky, *Monarchy Transformed*, 210.
64. Durston, *Cromwell's Major Generals*, 231.
65. Ibid., 154.
66. Ibid.
67. Ibid., 21.
68. Durston, "Whalley, Edward."
69. Ibid.
70. Gardiner, *History of the Commonwealth*, 242.
71. Ibid., 242.
72. Durston, *Cromwell's Major Generals*, 169.
73. Ibid., 171.
74. Ibid., 170.

75. Welles, *History of the Regicides*, 20.

76. Durston, *Cromwell's Major Generals*, 48.

77. Durston, "Whalley, Edward."

78. Durston, *Cromwell's Major Generals*, 48.

79. Ibid., 48.

80. Kishlansky, *Monarchy Transformed*, 210–11.

81. Durston, *Cromwell's Major Generals*, 178.

82. Durston, "Goffe, William."

83. Ibid.

84. Durston, *Cromwell's Major Generals*, 45.

85. Ibid.

86. Ibid., 48.

87. Durston, *Cromwell's Major Generals*, 191.

88. Ibid., 191–92.

89. Ibid., 197.

90. Ibid.

91. Ibid.

92. Ibid., 196.

93. Ibid., 200.

94. Ibid., 231.

95. Ibid., 219.

96. Ibid., 220–21.

97. Ibid., 221.

CHAPTER 9

98. Dunn, *Puritans and Yankees*, 120.

99. Major, *Literatures of Exile*, 155.

100. Bremer, *Puritan Experiment*, 121.

101. Ibid., 126.

102. Hale, "Puritan Politics," 453.

103. Bremer, *Puritan Experiment*, 125.

104. Hale, "Puritan Politics," 453.

105. Bremer, *Puritan Experiment*, 126.

106. Ibid., 125.

107. Ibid., 127.

108. Wilson, "Web of Secrecy," 525.

109. Ibid., 525.

110. Bremer, *Puritan Experiment*, 128–29.

111. Welles, *History of the Regicides*, 23–24.
112. Ibid., 24.

Chapter 10

113. Ibid., 25.
114. Dunn, *Puritans and Yankees*, 118.
115. Ibid.
116. Welles, *History of the Regicides*, 25.
117. Ibid.
118. Durston, "Whalley, Edward."
119. Welles, *History of the Regicides*, 28.
120. Ibid., 26.
121. Ibid., 27.
122. Ibid
123. Stiles, Doolittle and Moulthrop, *Three of the Judges*, 33–34.
124. Welles, *History of the Regicides*, 27.
125. Ibid.
126. Warren, *Three Judges Story*, 162–63.
127. Morrah, *1660, the Year of Restoration*, 184–85.
128. Ibid., 187.
129. Ibid., 209–10.
130. Ibid., 199.
131. Bremer, *Puritan Experiment*, 144.
132. Ibid.
133. Welles, *History of the Regicides*, 31.

Chapter 11

134. Ibid., 28–29.
135. Dunn, *Puritans and Yankees*, 118.
136. Bremer, *Puritan Experiment*, 146.
137. Welles, *History of the Regicides*, 31.
138. Ibid., 30.
139. Warren, *Three Judges Story*, 172.
140. Welles, *History of the Regicides*, 34.
141. Ibid., 31.
142. Ibid., 32.
143. Ibid., 34.

144. Ibid., 35.
145. Warren, *Three Judges Story*, 173–76.
146. Ibid., 176.
147. Welles, *History of the Regicides*, 37.
148. Ibid., 38.
149. Ibid., 39.
150. Ibid., 40.
151. Ibid.
152. Ibid., 41.
153. Ibid., 43.
154. Ibid., 41.
155. Ibid., 47.
156. Ibid., 48–49.
157. Ibid., 51.
158. Ibid., 52.
159. Ibid.
160. Ibid., 54.

CHAPTER 12

161. Stiles, Doolittle and Moulthrop, *Three of the Judges*, 90.
162. Welles, *History of the Regicides*, 58.
163. Ibid., 64.
164. Ibid., 67.
165. Ibid., 69–70.
166. Ibid., 58–59.
167. Ibid., 66–67.
168. Ibid., 72.
169. Ibid., 60.
170. Ibid., 19–20.
171. Ibid., 61.
172. Ibid., 63.
173. Ibid., 71.
174. Bremer, *Puritan Experiment*, 149.

CHAPTER 13

175. Welles, *History of the Regicides*, 73.
176. Lucas, "Colony or Commonwealth," 98.

177. Welles, *History of the Regicides*, 76.

178. Bremer, *Puritan Experiment*, 150.

179. Welles, *History of the Regicides*, 80.

180. Warren, *Three Judges Story*, 249.

181. Ibid., 253.

182. Welles, *History of the Regicides*, 80.

183. Ibid., 75.

184. Ibid., 82.

185. Warren, *Three Judges Story*, 253–55.

186. Ibid., 256.

187. Ibid., 251–52.

188. Welles, *History of the Regicides*, 85–88.

189. Ibid., 88.

190. Ibid., 88–89.

191. Judd, Boltwood and Sheldon, *History of Hadley*, xxii.

192. Welles, *History of the Regicides*, 90.

193. Ibid., 91.

194. Ibid., 92.

195. Wilson, "Web of Secrecy," 515.

196. Welles, *History of the Regicides*, 92.

197. Wilson, "Web of Secrecy," 542.

198. Ibid., 541.

199. Ibid., 542.

200. Welles, *History of the Regicides*, 95.

201. Wilson, "Web of Secrecy," 546.

202. Ibid.

203. Welles, *History of the Regicides*, 95–96.

CHAPTER 14

204. Ibid., 99.

205. Wilson, "Web of Secrecy," 547.

CHAPTER 15

206. Welles, *History of the Regicides*, 121.

207. Ibid., 110.

208. Ibid., 82.

209. Ibid.

210. Ibid.,109–10.
211. Ibid., 112–13.
212. Ibid., 109.
213. Peacey, "Dixwell, John."
214. Welles, *History of the Regicides*, 117.
215. Ibid., 113–15.
216. Ibid., 120.
217. Ibid., 118.

CHAPTER 16

218. Ibid., 116.
219. Sargent, "Thomas Hutchinson," 435.
220. Howe, *Changing Political Thought of John Adams*, 42.

CHAPTER 17

221. Wilson, "Landscape of Democracy," 30.
222. "Explore Thomas Cole."
223. Wilson, "Landscape of Democracy," 36.
224. Kelly, "Frederic Edwin Church."
225. Groft and Mackay, *Albany Institute of History & Art*, 96.
226. Hutson and Durrie, *George Henry Durrie*, 46.
227. Simkin, *George Henry Durrie*, 11–12.
228. Raynor, "Off the Wall."
229. Sargent, *Thomas Hutchinson*, 432.
230. Scott, *Peveril of the Peak*, ch. 14.
231. Sargent, *Thomas Hutchinson*, 444.
232. Ibid.

BIBLIOGRAPHY

Adams, John, and C. Bradley Thompson. *The Revolutionary Writings of John Adams*. Indianapolis: Liberty Fund, 2000.

Aronson, Marc. *John Winthrop, Oliver Cromwell, and the Land of Promise*. New York: Clarion Books, 2004.

Ashley, Maurice. *The Battle of Naseby and the Fall of King Charles I*. New York: St. Martin's Press, 1992.

Block, Elizabeth. "Figuring Thomas Pritchard Rossiter." Accessed January 2011. www.homehudson.com/catalogue/papers/Block_Elizabeth.pdf.

Bremer, Francis J. *The Puritan Experiment: New England Society from Bradford to Edwards*. New York: St. Martin's Press, 1995.

Carruthers, Bob. *The English Civil Wars, 1642–1660*. London: Cassell, 2000.

Clary, Ian H. "Hot Protestants: A Taxonomy of English Puritanism." Toronto Baptist Seminary, Academia.edu. Accessed February 18, 2012. tbs.academia.edu/IanClary/Papers/242024/Hot_Protestants_A_Taxonomy_of_English_Puritanism.

Cooper, James Fenimore. *The Wept of Wish-ton-Wish*. New York: Stringer and Townsend, 1852. Accessed January 2012. books.google.com.

Copplestone, Trewin. *The Hudson River School*. New York: Gramercy, 1999.

Coward, Barry. *The Stuart Age: A History of England 1603–1714*. London: Longman, 1980.

Crawford, Patricia. "Charles I, That Man of Blood." *Journal of British Studies* 16, no. 2 (Spring 1977): 41–61. Accessed February 2009. www.jstor.org/stable/175359.

Dexter, Franklin Bowditch. *Memoranda Concerning Edward Whalley and William Goffe.* N.p.: Tuttle, Morehouse and Taylor, 1876.

Dunn, Richard S. *Puritans and Yankees: The Winthrop Dynasty of New England, 1630–1717.* New York: W.W. Norton, 1971.

Durston, Christopher. *Cromwell's Major Generals: Godly Government during the English Revolution.* Manchester, UK: Manchester University Press, 2001.

———. "Goffe, William (d. 1679?)." Oxford Dictionary of National Biography. Accessed July 2011. www.oxforddnb.com.

———. "Whalley, Edward, Appointed Lord Whalley under the Protectorate (d. 1674/5)." Oxford Dictionary of National Biography. Accessed July 9, 2011. www.oxforddnb.com.

"Explore Thomas Cole | About." Explore Thomas Cole | Home. Accessed January 9, 2012. www.explorethomascole.org/about.

Fraser, Antonia. *Cromwell, the Lord Protector.* New York: Knopf, 1973.

———. *Cromwell, Our Chief of Men.* London: Weidenfeld and Nicolson, 1973.

Gardiner, Samuel Rawson. *History of the Commonwealth and Protectorate 1649–1660.* London: Longmans, Green, 1897.

Gaunt, Peter. *Oliver Cromwell.* New York: New York University Press, 2004.

Glover, Samuel D. "The Putney Debates: Popular versus Elitist Republicanism." *Past & Present* 164, no. 1 (1999): 47–80. Accessed February 2009. doi:10.1093/past/164.1.47.

Greenhouse, Wendy. "Karl Anderson." Terra Foundation for American Art: Collections. Accessed January 9, 2012. collections.terraamericanart.org/view/people/asitem/items$0040null:125/0.

Griffin, Emma. *Blood Sport: Hunting in Britain since 1066.* New Haven, CT: Yale University Press, 2007.

Groft, Tammis Kane, and Mary Alice Mackay. *Albany Institute of History & Art: 200 Years of Collecting.* New York: Hudson Hills Press in Association with Albany Institute of History & Art, 1998.

Hale, Edward E. "Puritan Politics of England and New England." In *Lectures Delivered in a Course before the Lowell Institute, in Boston by Members of the Massachusetts Historical Society on Subjects Relating to the Early History of Massachusetts,* by Chandler Robbins. Boston: Published by the Society, 1869.

Haverstock, Mary Sayre, Jeannette Mahoney Vance, Brian L. Meggitt and Jeffrey Weidman. *Artists in Ohio, 1787–1900: A Biographical Dictionary.* Kent, OH: Kent State University Press, 2000. Accessed January 2012. books.google.com.

Hawthorne, Nathaniel. *The Snow-image and Other Twice-told Tales.* Boston: Ticknor, Reed, and Fields, 1852. Accessed January 2012. books.google.com.

Howe, John R. *The Changing Political Thought of John Adams.* Princeton, NJ: Princeton University Press, 1966.

Hutson, Martha Young, and George Henry Durrie. *George Henry Durrie, 1820–1863: American Winter Landscapist, Renowned through Currier and Ives.* Santa Barbara, CA: Santa Barbara Museum of Art, 1977.

Hutton, Ronald. *The British Republic, 1649–1660.* New York: St. Martin's Press, 1990.

Judd, Sylvester, Lucius M. Boltwood and George Sheldon. *The History of Hadley, Massachusetts.* Somersworth, NH: New Hampshire Pub., 1976.

"Karl Anderson (1874–1956)." Spanierman Gallery American Art from the 19th Century to the Present. Accessed February 09, 2012. www.spanierman.com/Anderson,-Karl/bio/thumbs/biography.

Kelly, Franklin. "Frederic Edwin Church West Rock." New Britain Museum of Art. Accessed January 8, 2011. nbmaa.org.

Kishlansky, Mark A. *A Monarchy Transformed: Britain 1603–1714.* New York: Penguin, 1997.

———. *The Rise of the New Model Army.* Cambridge, UK: Cambridge University Press, 1979.

Lorrance, Nancy. "Connecticut New Deal Art." New Deal/WPA Art Project. Accessed January 23, 2012. www.wpamurals.com/Connecticut.html.

Lucas, Paul R. "Colony or Commonwealth: Massachusetts Bay, 1661–1666." *William and Mary Quarterly* 24, no. 1 (January 1967): 88–107. Accessed February 2009. www.jstor.org/stable/1920563.

Major, Philip. *Literatures of Exile in the English Revolution and Its Aftermath, 1640–1690.* Burlington, VT: Ashgate, 2010.

Miller, Marla R. *Cultivating a Past: Essays on the History of Hadley, Massachusetts.* Amherst: University of Massachusetts Press, 2009.

Morrah, Patrick. *1660, the Year of Restoration.* Boston: Beacon Press, 1961.

Oriens, Harrison G. "Angel of Hadley in Fiction." *American Literature* 4, no. 3 (November 1932): 257–69. Accessed February 19, 2009. www.jstor.org/stable/2919881.

Peacey, Jeffrey T. "Dixwell, John [James Davids] (c. 1607–1689)." In *Oxford Dictionary of National Biography.* Oxford: Oxford University Press, 2004. Accessed February 2012. www.oxforddnb.com/view/article/7710.

Phillips, James. "William Goffe the Regicide." *English Historical Review* 7, no. 28 (1892): 717–20. Accessed February 2009. doi:10.1093/ehr/VII.XXVIII.717.

Plant, David. "British Civil Wars, Commonwealth and Protectorate, 1638–60." Accessed August 9, 2011. www.british-civil-wars.co.uk.

Raynor, Patricia. "Off the Wall: New Deal Post Office Murals." National Postal Museum. Accessed February 9, 2012. www.postalmuseum.si.edu/resources/6a2q_postalmurals.html.

Robbins, Chandler. "The Regicides Sheltered in New England." In *Lectures Delivered in a Course before the Lowell Institute, in Boston*. Boston: Society, 1869.

Sachse, William L. "England's 'Black Tribunal': An Analysis of the Regicide Court." *Journal of British Studies* 12, no. 2 (May 1973): 69. Accessed February 2009. doi:10.1086/385642.

Sargent, Mark L. "Thomas Hutchinson, Ezra Stiles, and the Legend of the Regicides." *William and Mary Quarterly* 49, no. 3 (July 1992): 431–48.

Scott, Walter. *Peveril of the Peak*. Edinburgh: Archibald Constable, 1822. Accessed January 2012. www.online-literature.com.

Simkin, Colin. *George Henry Durrie, Connecticut Artist, 1820–1863 (Catalogue by Colin Simkin Of) an Exhibition, April 20–June 1, 1966…New Haven Colony Historical Society…New Haven, Connecticut*. New Haven, CT: New Haven Colony Historical Society, 1966.

Steiner, Bernard C. *History of Guilford and Madison, Connecticut*. Guilford, CT: Guilford Free Library, 1975.

Stiles, Ezra, Amos Doolittle and Reuben Moulthrop. *A History of Three of the Judges of King Charles I Major-General Whalley, Major-General Goffe, and Colonel Dixwell: Who, at the Restoration, 1660, Fled to America; and Were Secreted and Concealed, in Massachusetts and Connecticut, for near Thirty Years: With an Account of Mr. Theophilus Whale, of Narragansett, Supposed to Have Been Also One of the Judges*. Hartford, CT: Printed by Elisha Babcock, 1794.

Underdown, David. *Pride's Purge: Politics in the Puritan Revolution*. Oxford, UK: Clarendon Press, 1971.

Warren, Israel P. *The Three Judges Story of the Men Who Beheaded Their King*. New York: Warren and Wyman, 1873.

Wedgwood, C.V., and A.L. Rowse. *A Coffin for King Charles: The Trial and Execution of Charles I*. New York: Time, 1966.

Welles, Lemuel Aiken. *The History of the Regicides in New England*. New York: Grafton Press, 1927.

Wilson, Christopher K. "The Landscape of Democracy: Frederick Church's 'West Rock, New Haven.'" *American Art Journal* 18, no. 3 (Summer 1986): 20–39. Accessed February 4, 2009. www.jstor.org/stable/1594440.

BIBLIOGRAPHY

Wilson, Douglas C. "Web of Secrecy: Goffe, Whalley, and the Legend of Hadley." *New England Quarterly* 60, no. 4 (December 1987): 515–48. Accessed February 2009. www.jstor.org/stable/365416.

Woodhouse, Arthur Sutherland Pigott, and William Clarke. *Puritanism and Liberty*. Chicago: University of Chicago Press, 1951.

ABOUT THE AUTHOR

Courtesy of Kris Connors.

Chris Pagliuco is a freelance writer who specializes in seventeenth-century colonial history. His interest in the regicides originated in his graduate studies in history at Trinity College in Hartford, Connecticut. He teaches high school history in Madison, Connecticut, and serves as town historian in Essex, Connecticut, and on the editorial team of *Connecticut Explored*, a quarterly history publication. He lives with his wife, two daughters and two dogs in Ivoryton, Connecticut. This is his first book.

Visit us at
www.historypress.net